HAMPSHIRE IN PHOTOGRAPHS

MATTHEW PINNER

AMBERLEY

ACKNOWLEDGEMENTS

I would like to start by saying that I am entirely grateful to so many of the people who are close to me for supporting me while creating this book. First and most important is my beautiful wife, Emma: you have been my rock through this process and I love you very much. Also, my family: my mum, dad, brother and sister. Thank you for encouraging me after my first book and standing by me. My new family members, Ian, Debbie and Ben, for also believing in me and helping in any way when it comes to my photography.

There are also many members within the industry who have supported and guided me that I would like to give a special mention: Canon UK & Ireland, Angela Nicholson from *Camera Jabber*, Simon Parkin from *Somerset Weather*, Dean Murray from *Cover Images*, Corin Messer from *Bournemouth Echo*, Holly Green from *ITV Weather*, Elliot Wagland, John Challis, *Hampshire Life* magazine, Paul Vass, Gareth Richman and Elie Gordon from *BBC Earth*.

First published 2018

Amberley Publishing
The Hill, Stroud
Gloucestershire, GL5 4EP

www.amberley-books.com

Copyright © Matthew Pinner, 2018

The right of Matthew Pinner to be identified as the Author of this work has been asserted in accordance with the Copyrights, Designs and Patents Act 1988.

ISBN 978 1 4456 8203 7 (print)
ISBN 978 1 4456 8204 4 (ebook)

British Library Cataloguing in Publication Data.
A catalogue record for this book is available from the British Library.

Origination by Amberley Publishing.
Printed in the UK.

FOREWORD BY SIMON PARKIN

I've been very fortunate that I've been to some incredible places all over the world, thanks to my career. Now, obviously I always took my camera with me to capture the magic of the locations, but the results were at best passable and at worst terrible. But then I'm no Matt Pinner!

Matt doesn't just know what will make a great photo, he also has the natural talent to bring out the best in every picture he takes; the view, the composition, the lighting, he just instinctively knows how to get it right. Matt has that rare gift to take pictures of places that make the viewer feel as if they're almost there too.

INTRODUCTION

I first became interested in photography after my grandfather sadly passed away and left his tripod in his will for me. I found the inspiration from there, and have never looked back. I live by saying that you miss every shot you don't take. In any moment I have a chance. I'm constantly researching the next place to capture with my camera and when I'm free to explore I'm roaming around the UK's southern coast to capture as many images as I possibly can.

All the images within this book have been largely collected over the last year. While taking these images I explored as much of the county of Hampshire as I possibly could, so I have chosen the ones that mean something to me.

I love photography so much and I enjoy sharing the magical views I see in the early hours and last minutes of the day. I hope you enjoy the book as much as I enjoyed creating it.

ABOUT THE PHOTOGRAPHER

Matthew Pinner was born and raised for the early part of his life in the city of Southampton, Hampshire. After deciding at the age of twenty-two that he wanted to take up photography, he purchased his first camera after being left a tripod by his grandfather. It was his mission to learn everything he could by himself.

Matt's gallery of work is constantly expanding, along with the requests for a book of his work. The inspiration behind this book is to show the pure beauty of the county of Hampshire, which has been a massive part of his childhood. His large social media following, which reaches nearly 200,000 people, is also a constant source of inspiration for him.

Matt has achieved so much over the course of his five-year photography career, and many major TV outlets, newspapers and magazines have regularly asked to use his spectacular images to best represent the UK landscapes.

While on his photography outings Matt uses a Canon 5D Mark IV with a range of lenses by Canon. He uses a wide range of filters by Cokin.

Website: http://pinners-photography.co.uk
Facebook: Pinner's Photography
Twitter: @Matt_Pinner
Instagram: @Matt_Pinner
Email: enquiriespinnersphotogrpahy@gmail.co.uk

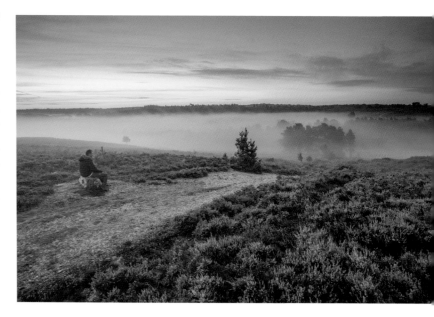

SPRING

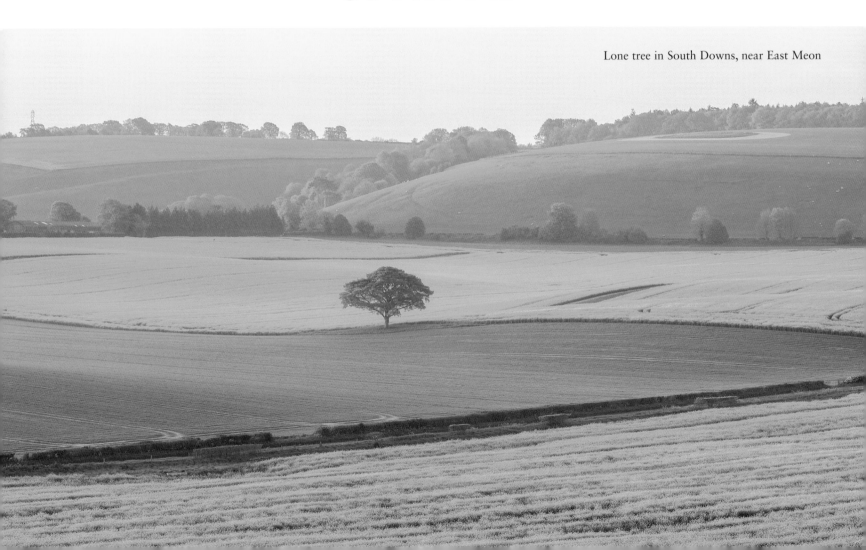

Lone tree in South Downs, near East Meon

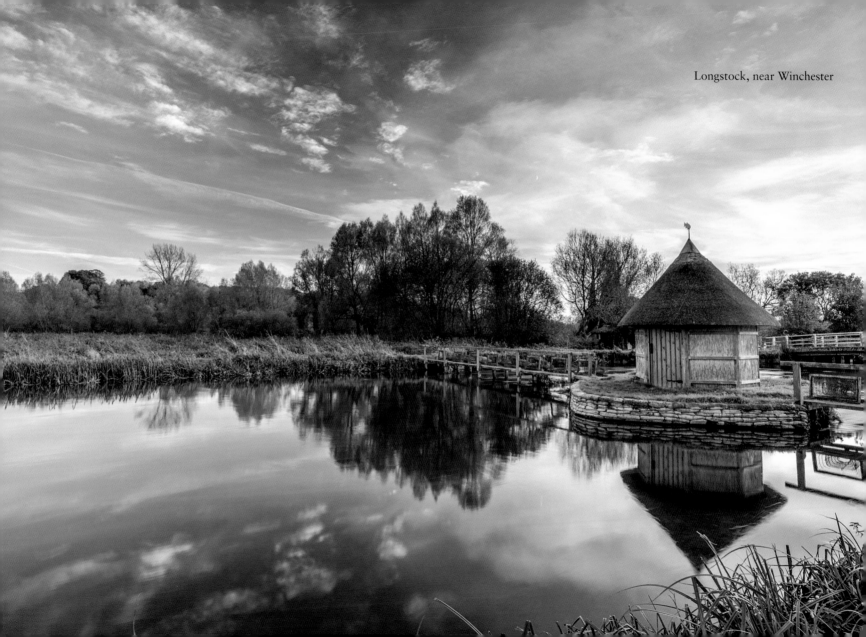

Longstock, near Winchester

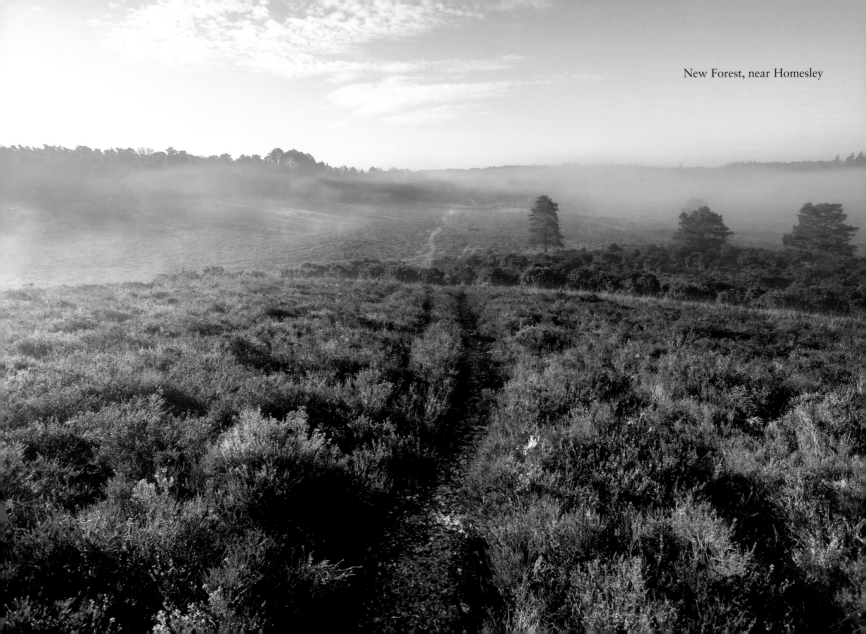

New Forest, near Homesley

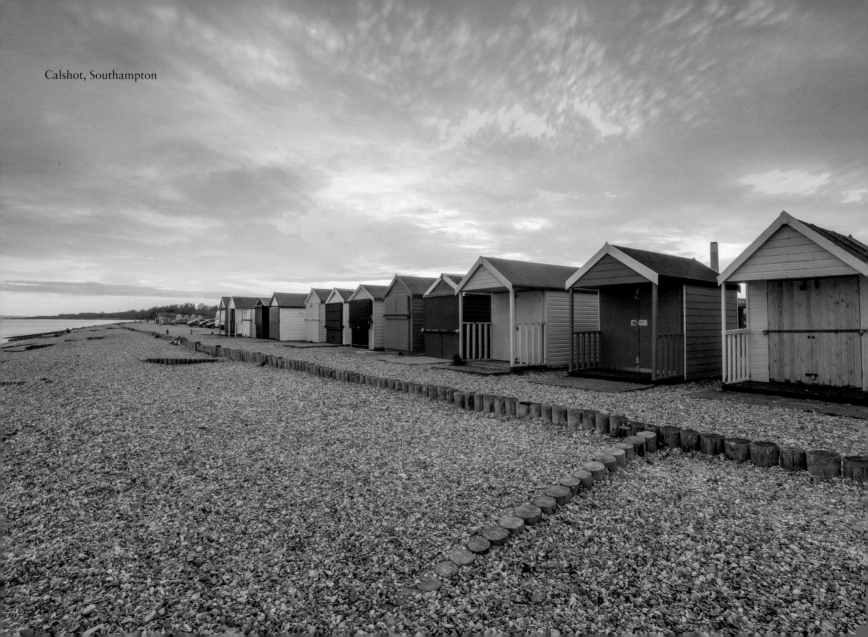

Calshot, Southampton

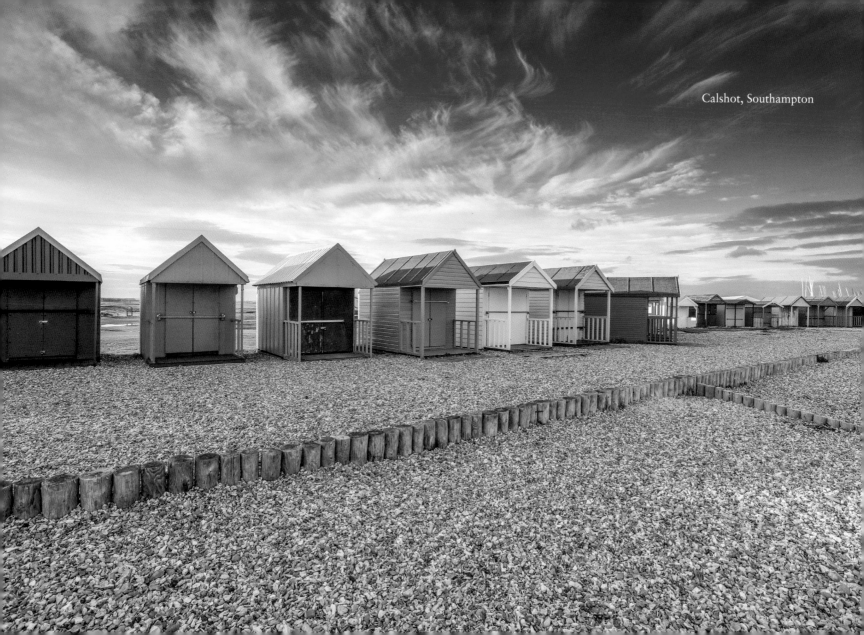

Calshot, Southampton

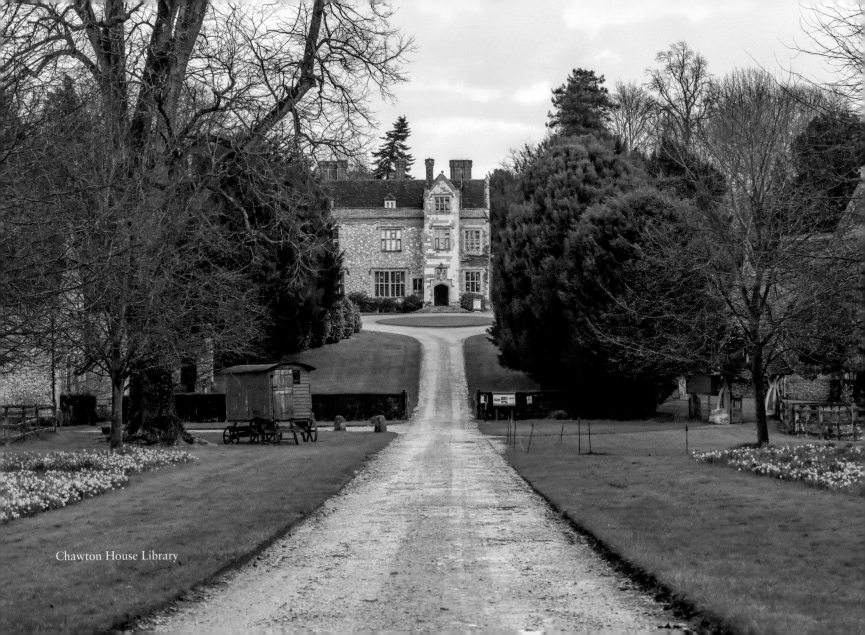

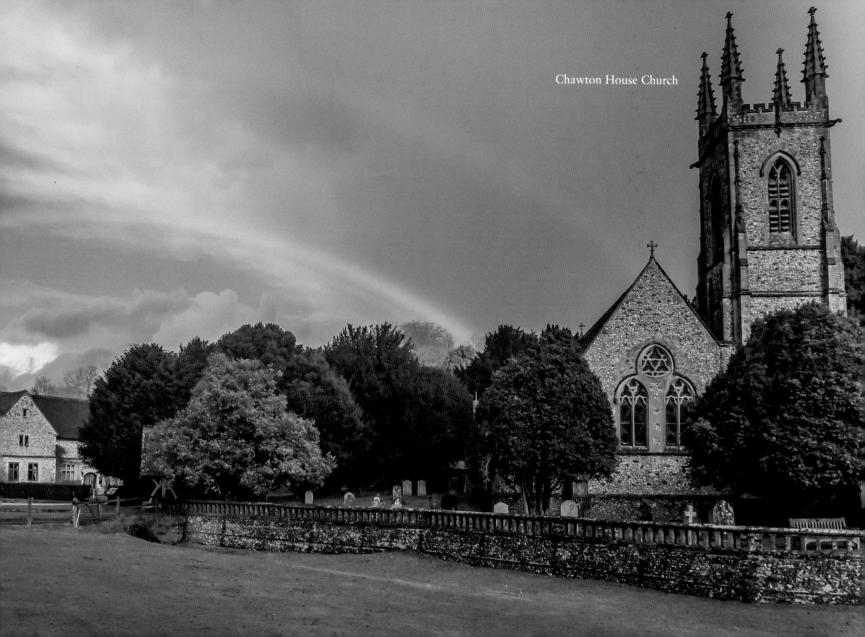

Chawton House Church

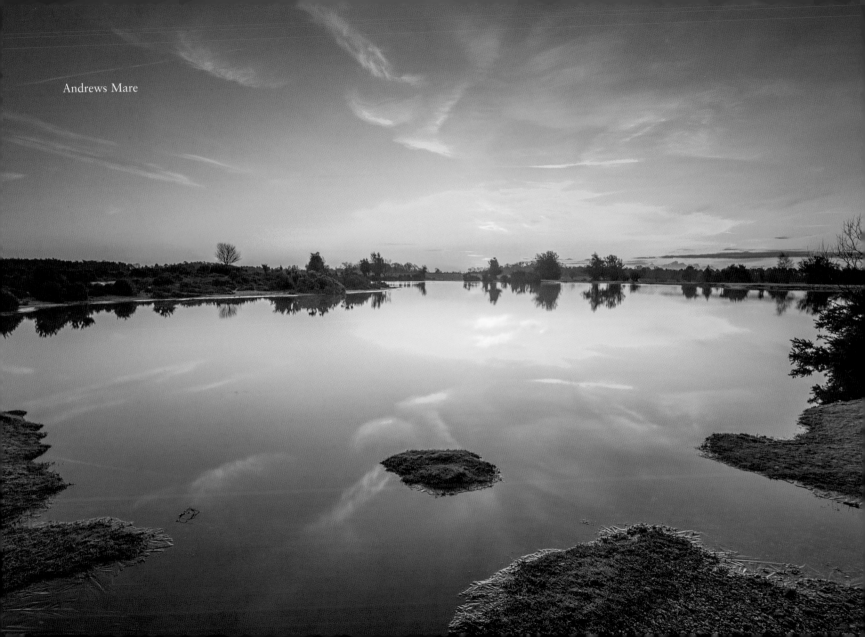

Andrews Mare

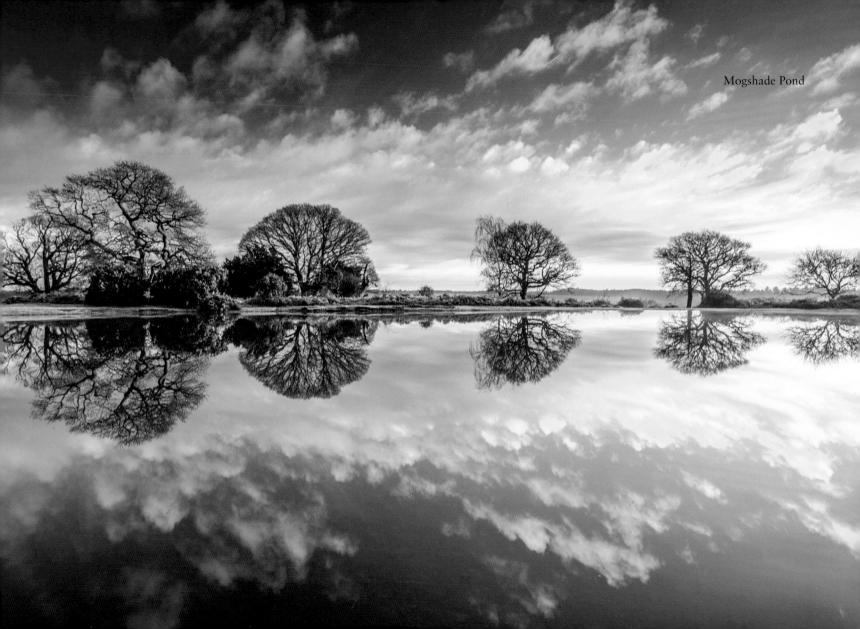

Mogshade Pond

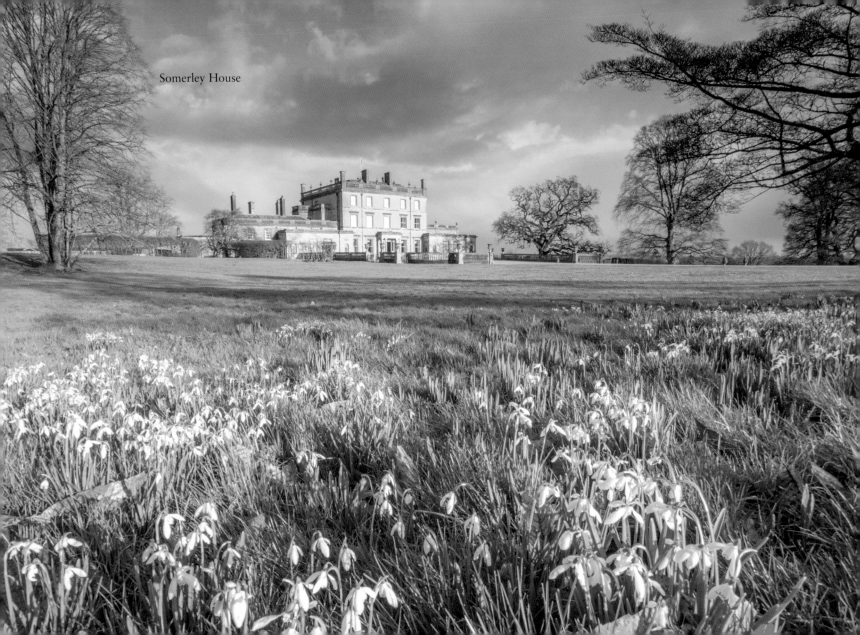
Somerley House

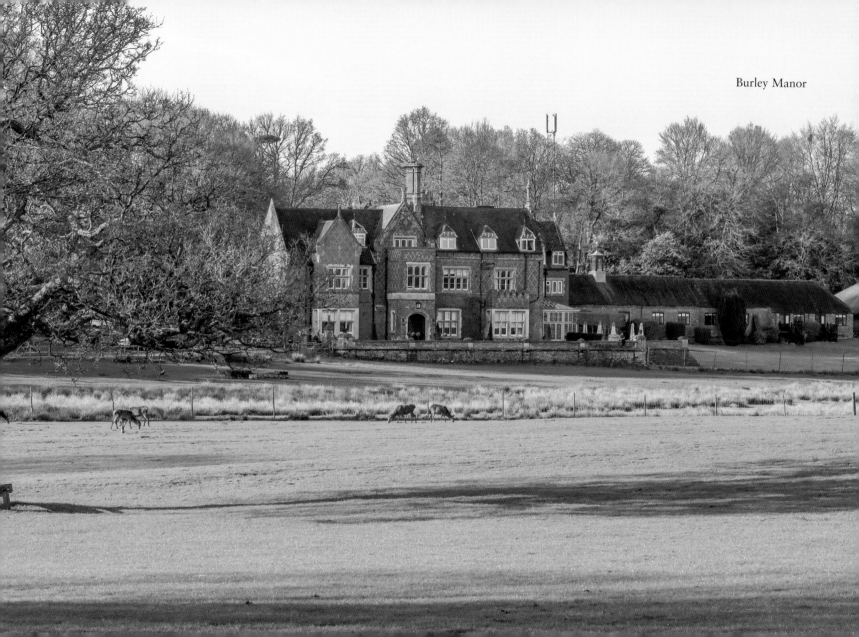

Burley Manor

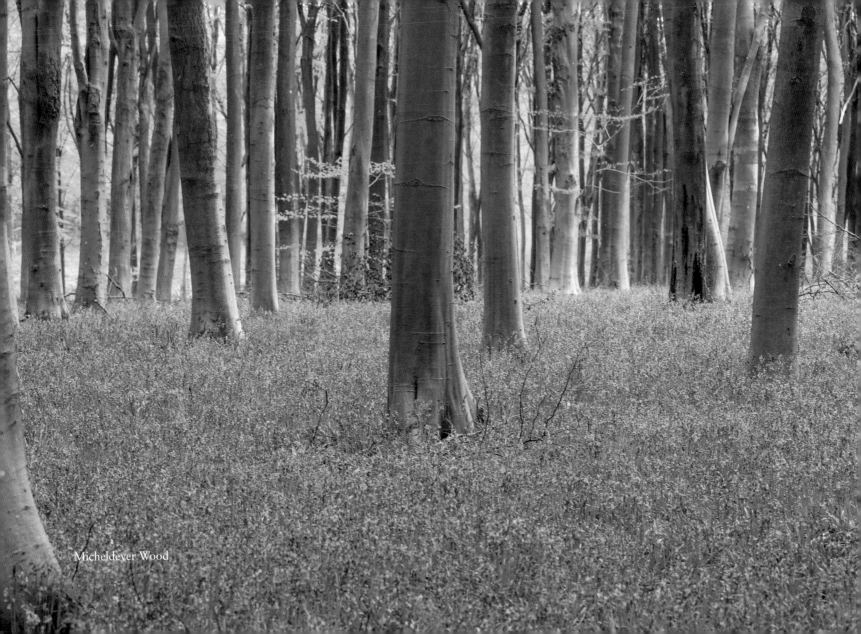

Micheldever Wood

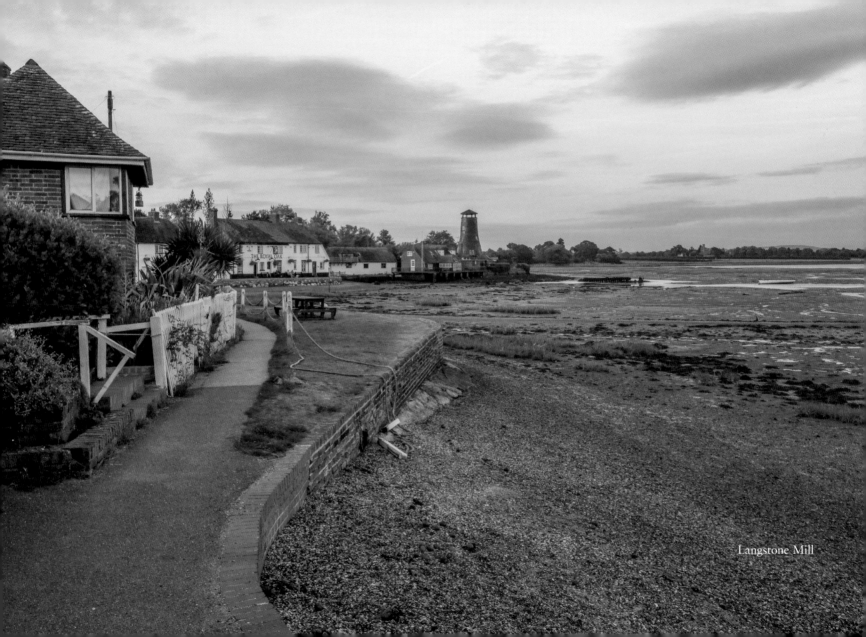

Langstone Mill

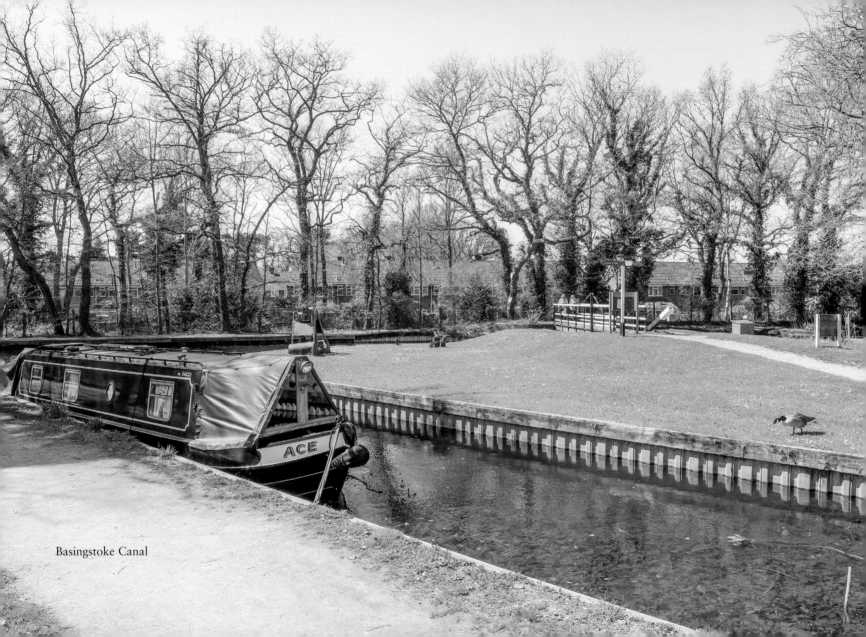

Basingstoke Canal

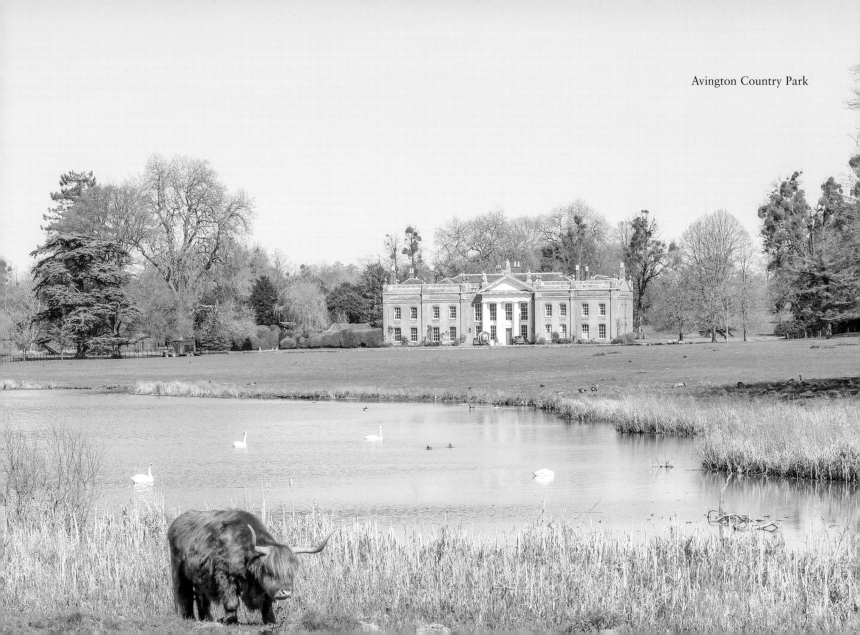

Avington Country Park

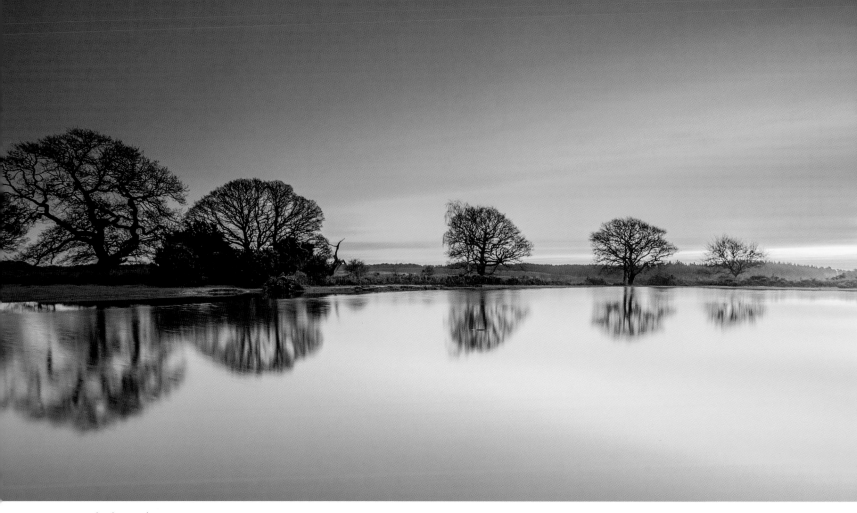

Mogshade Pond

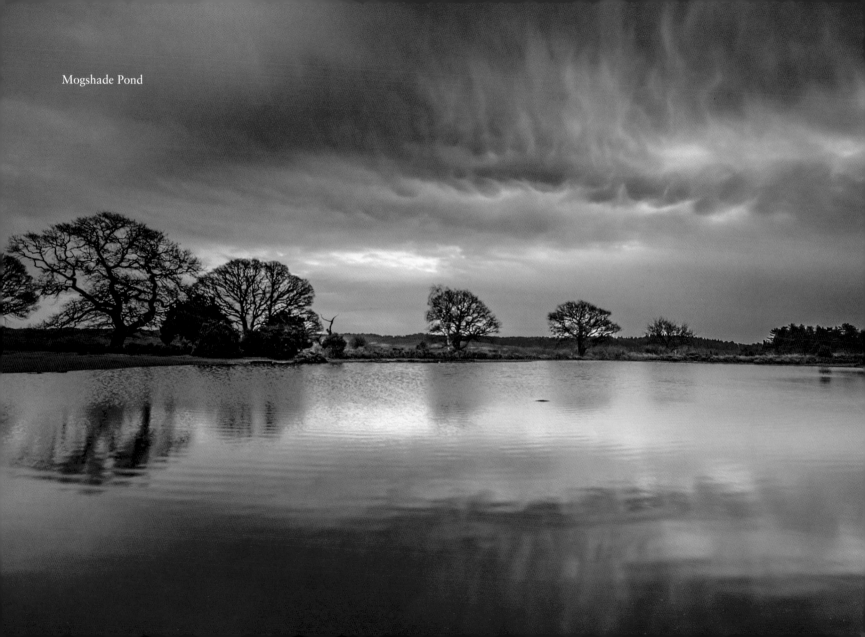

Mogshade Pond

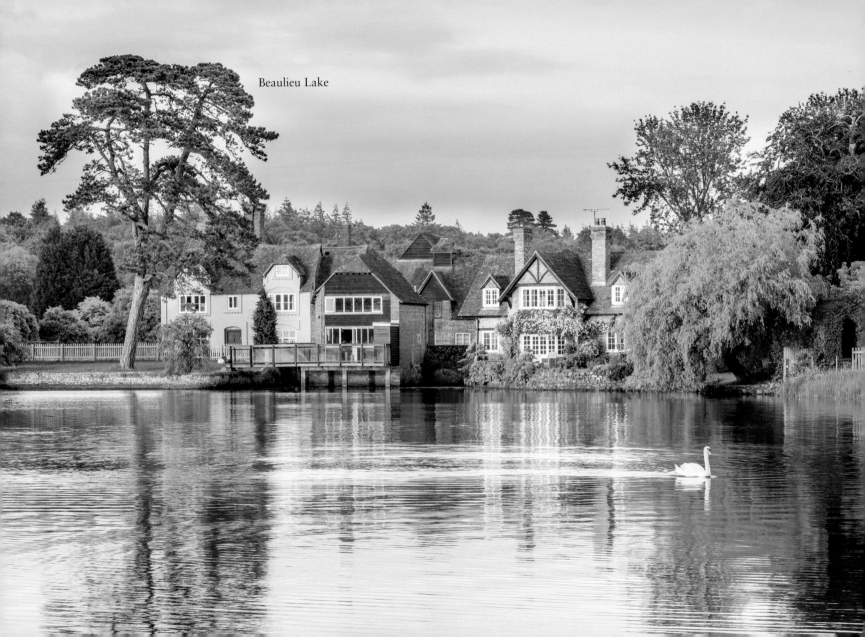

Beaulieu Lake

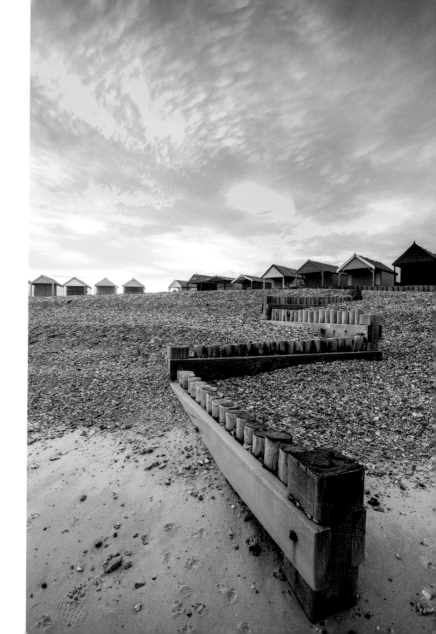

Calshot, Southampton

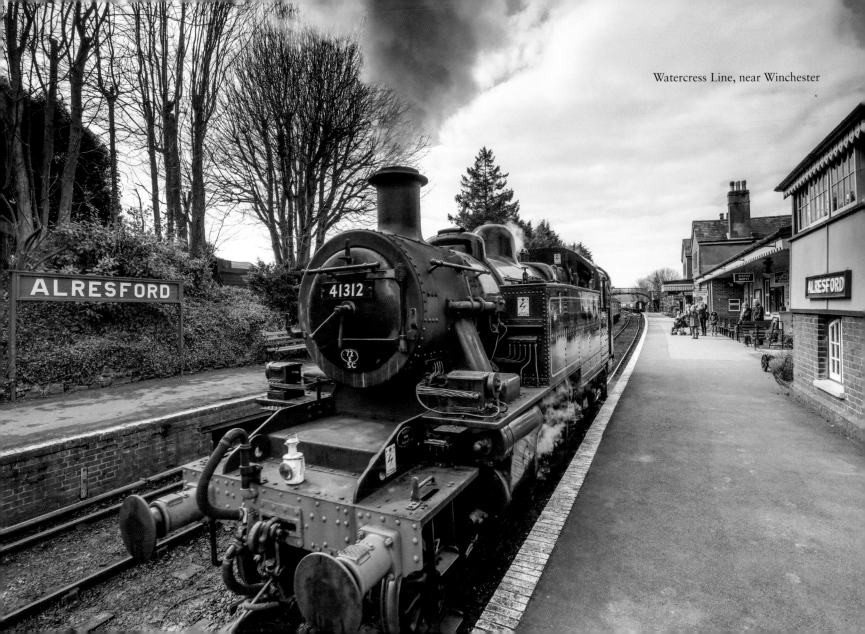

Watercress Line, near Winchester

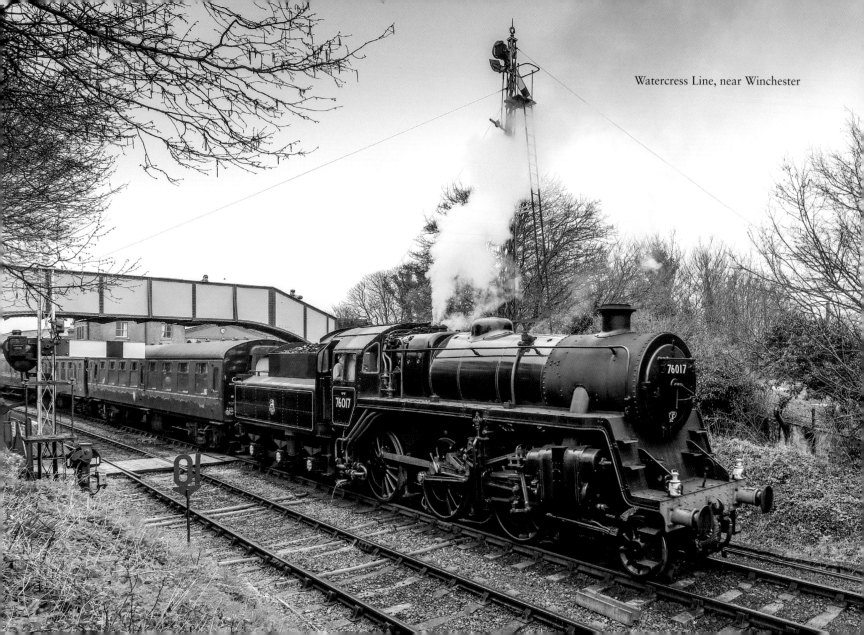

Watercress Line, near Winchester

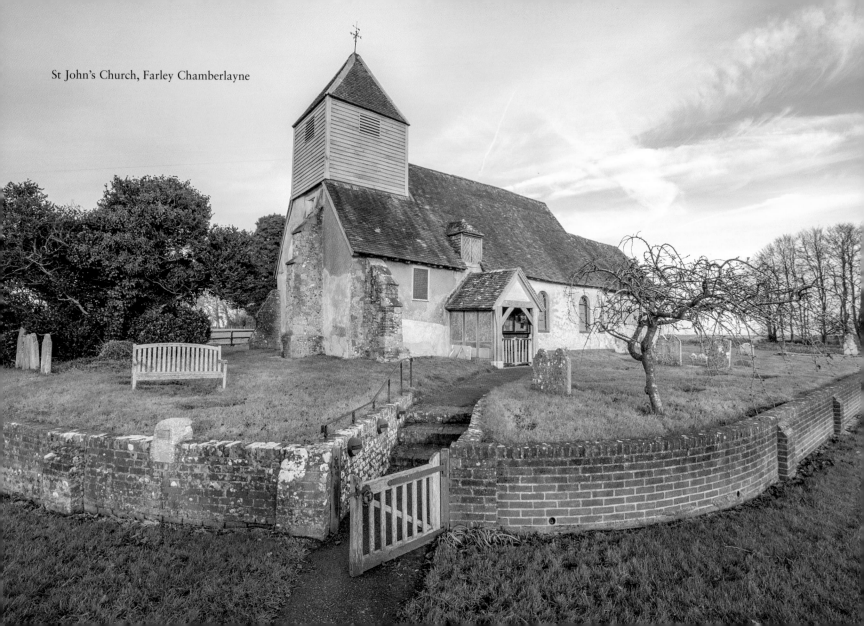

St John's Church, Farley Chamberlayne

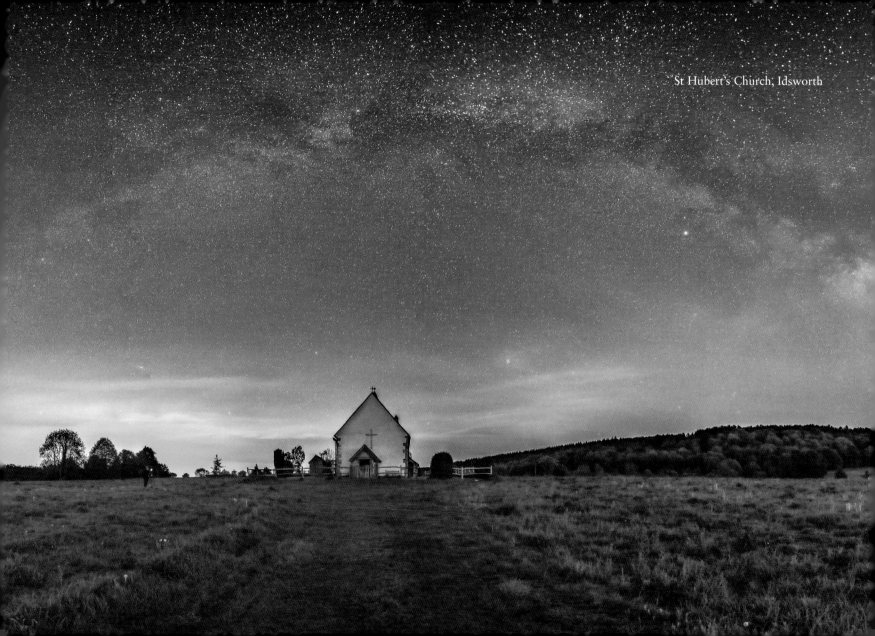

St Hubert's Church, Idsworth

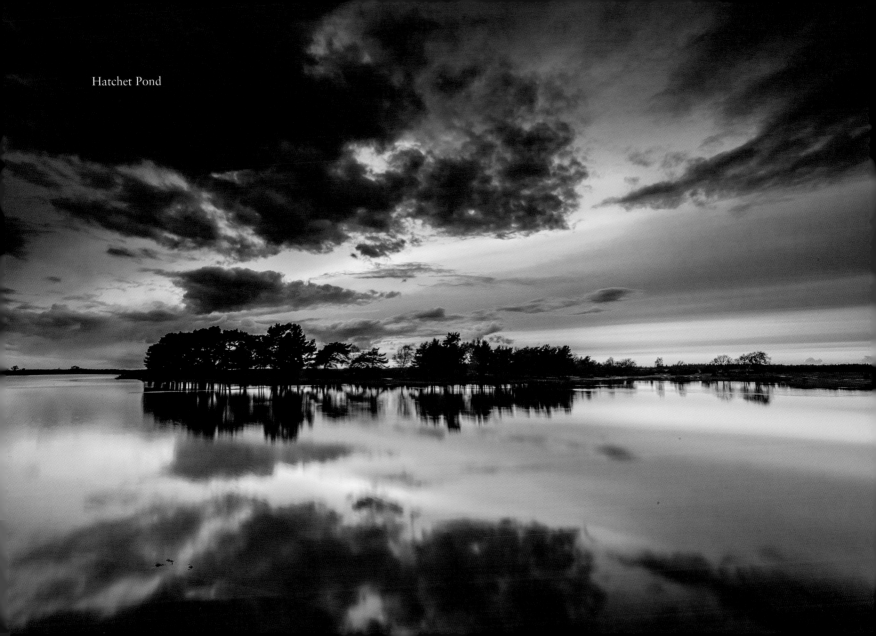

Hatchet Pond

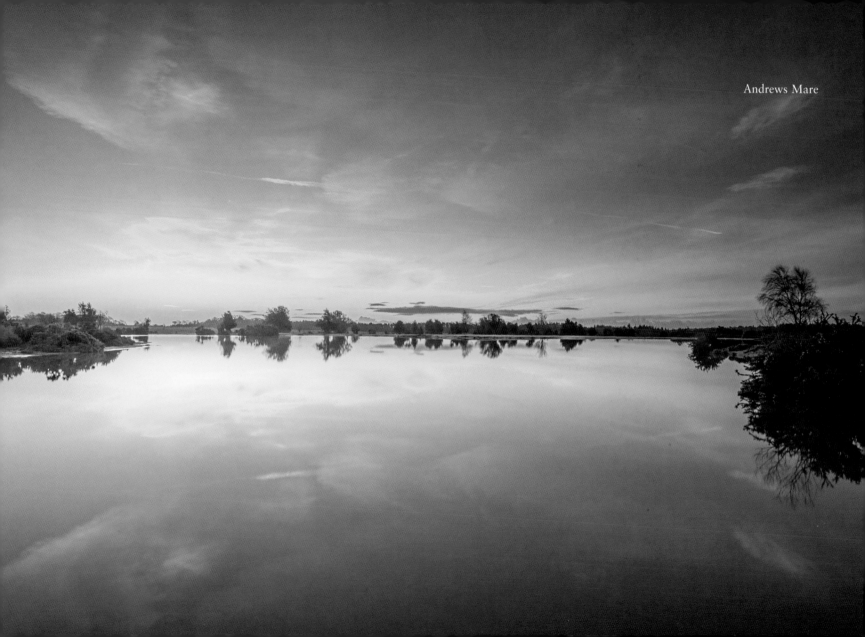

Andrews Mare

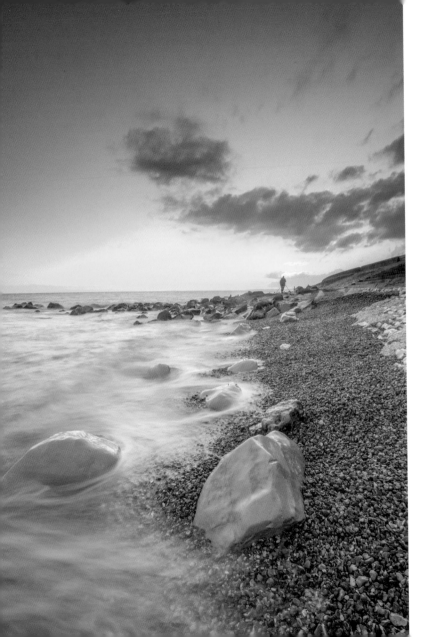

Milford-on-Sea

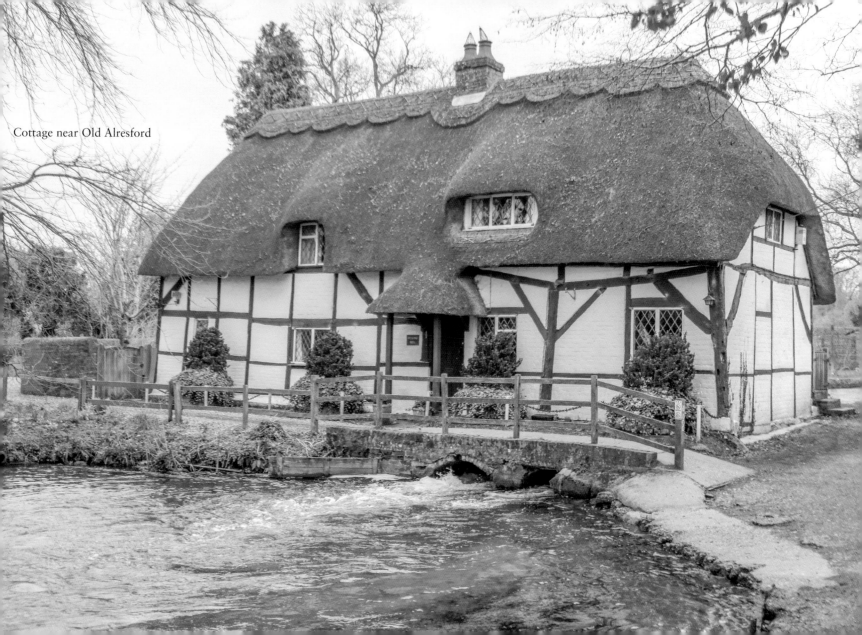

Cottage near Old Alresford

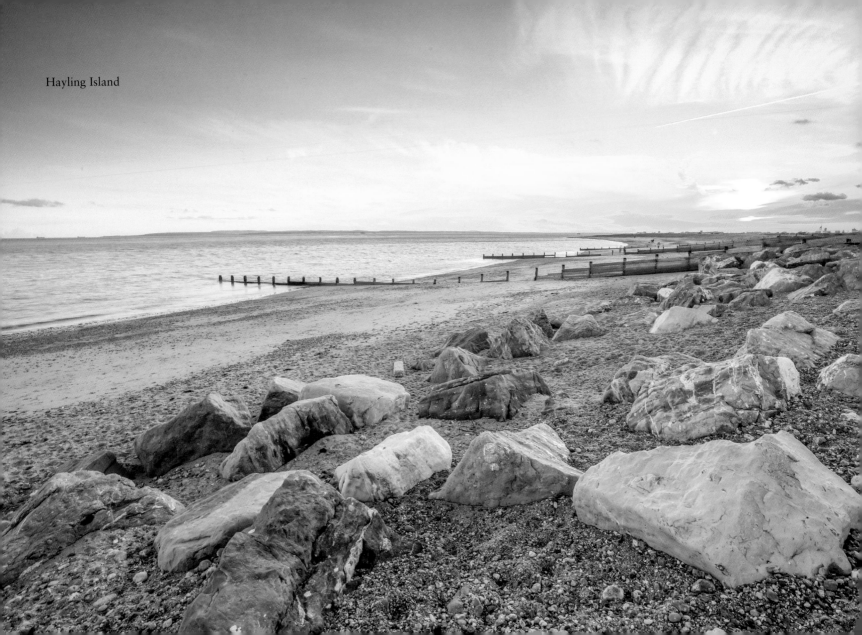

Hayling Island

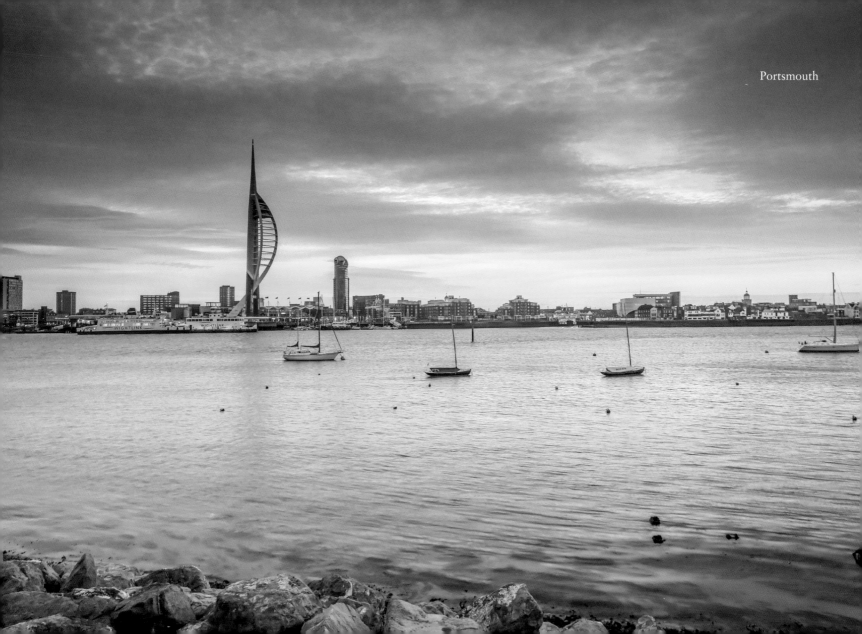

Portsmouth

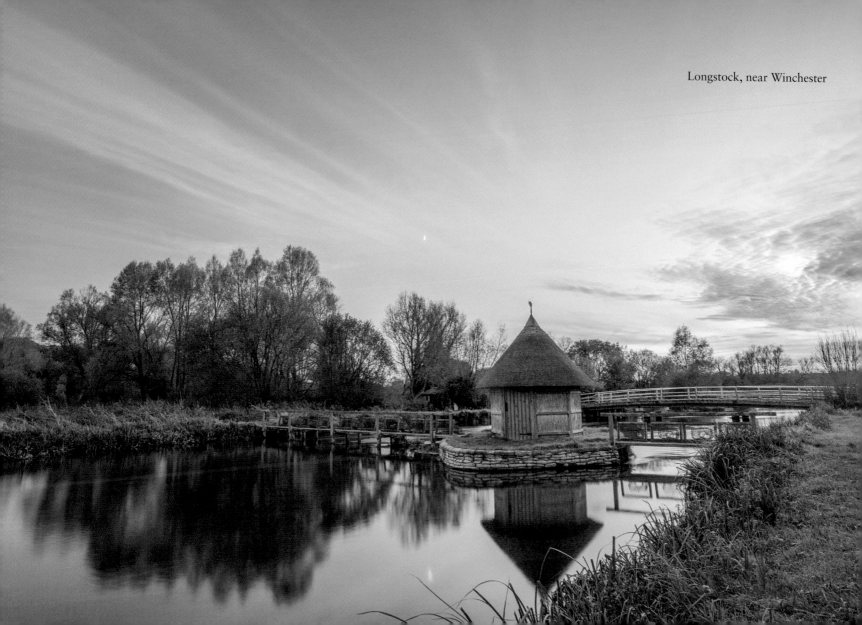

Longstock, near Winchester

SUMMER

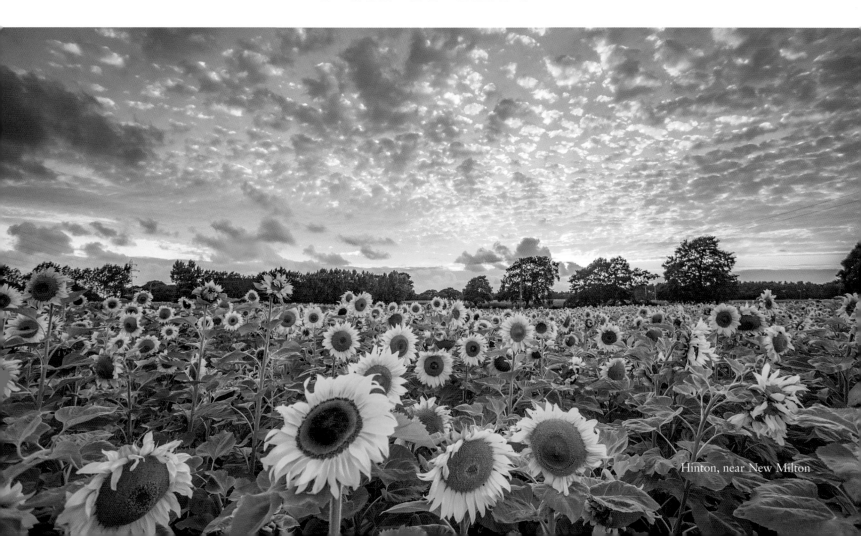

Hinton, near New Milton

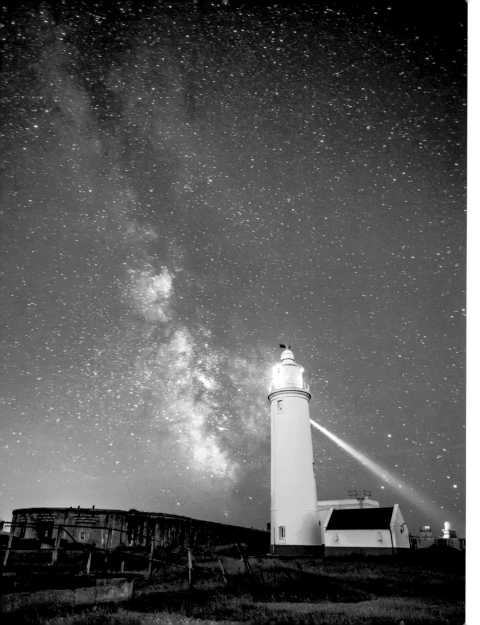

Hurst Castle

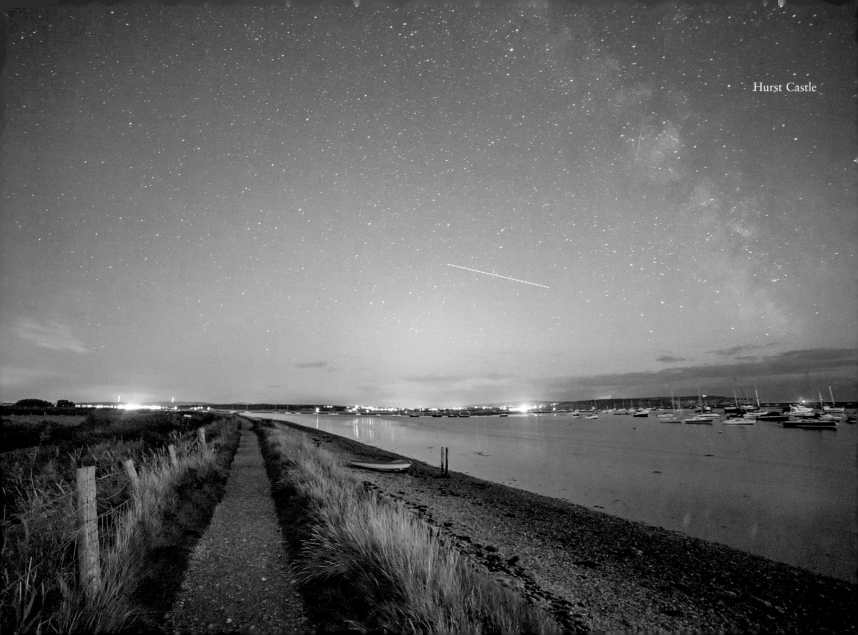

Hurst Castle

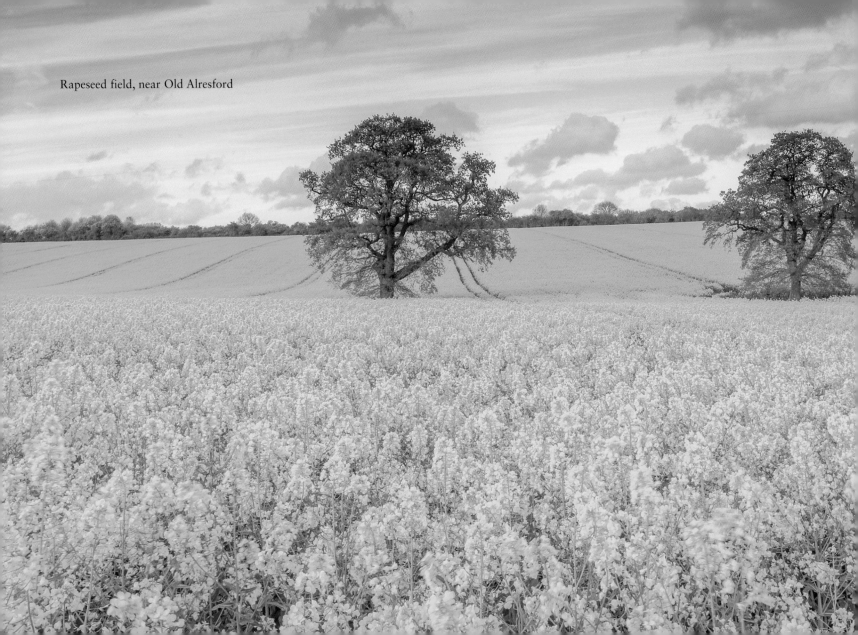

Rapeseed field, near Old Alresford

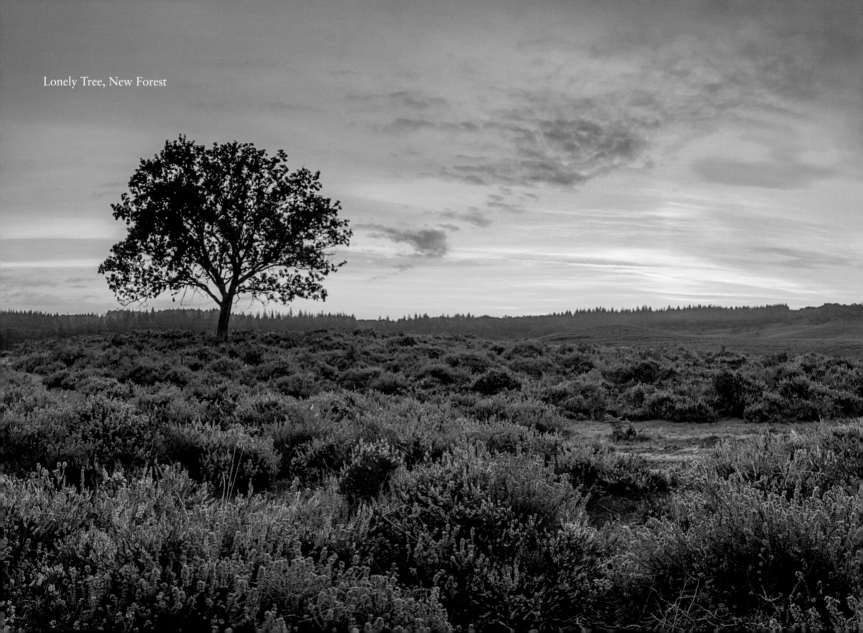

Lonely Tree, New Forest

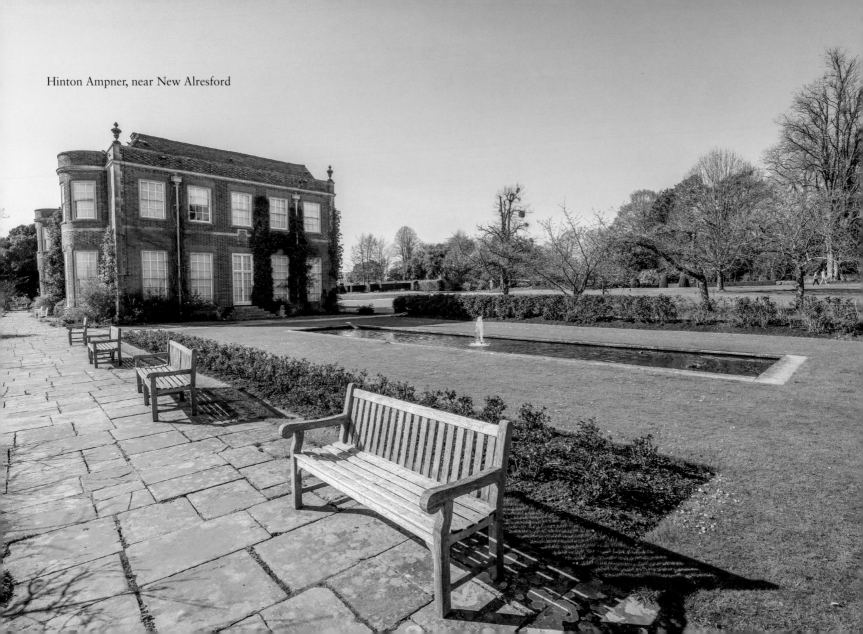

Hinton Ampner, near New Alresford

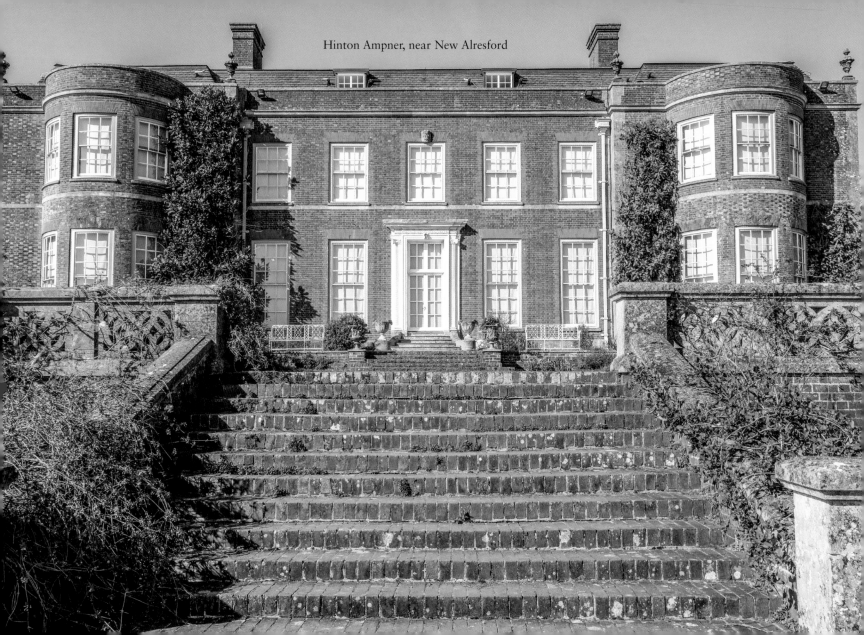

Hinton Ampner, near New Alresford

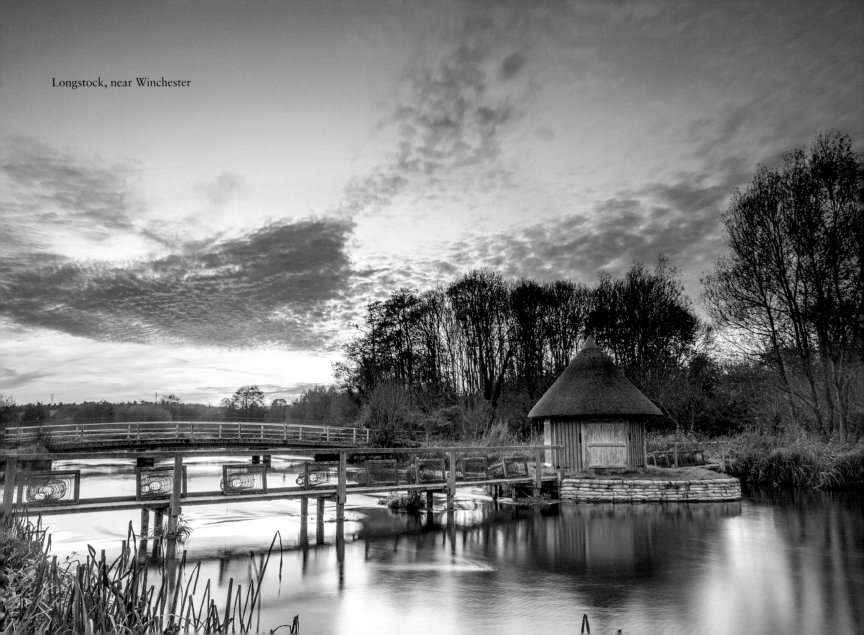

Longstock, near Winchester

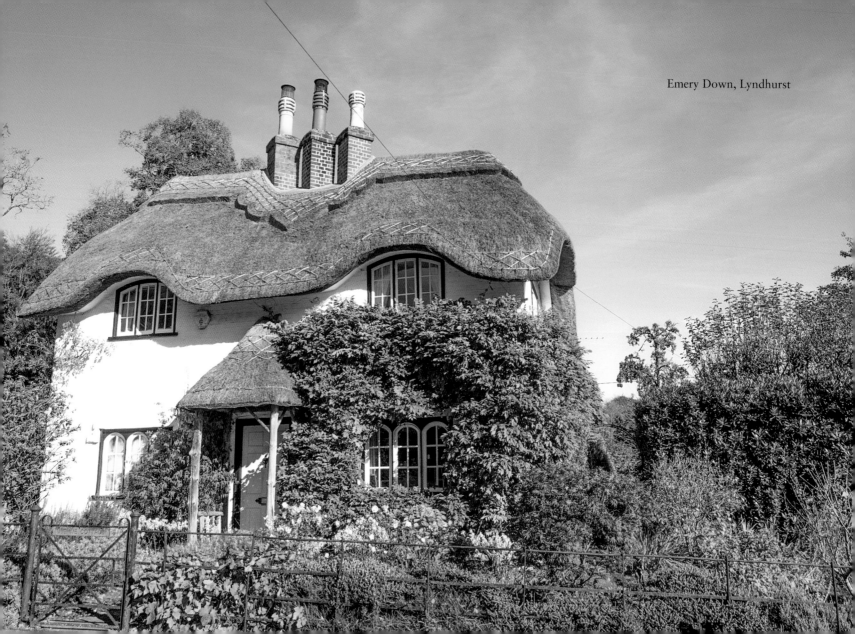

Emery Down, Lyndhurst

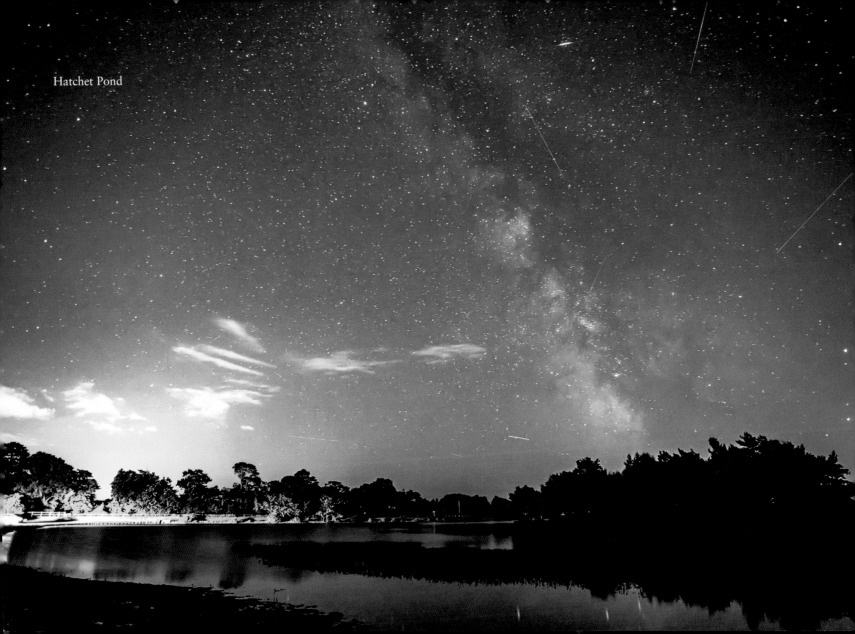

Hatchet Pond

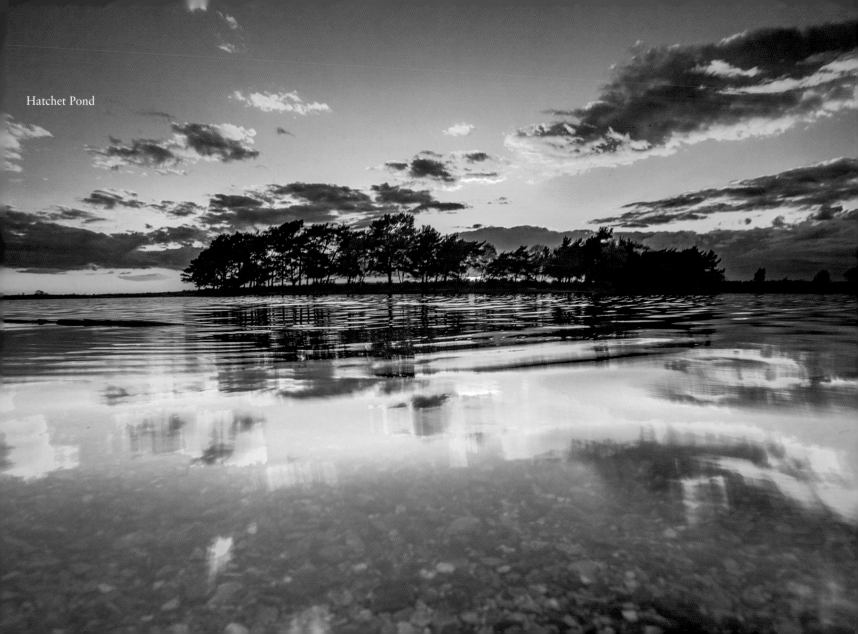

Hatchet Pond

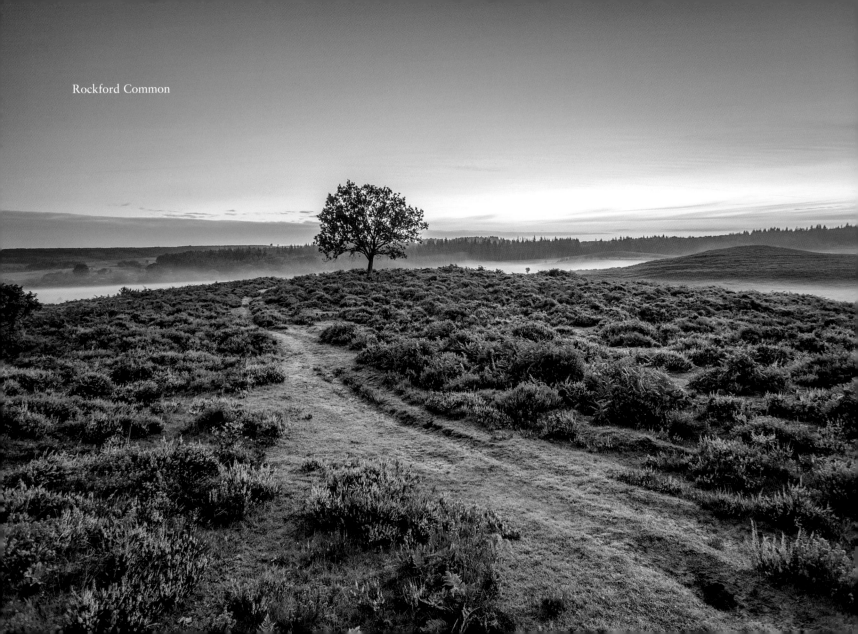

Rockford Common

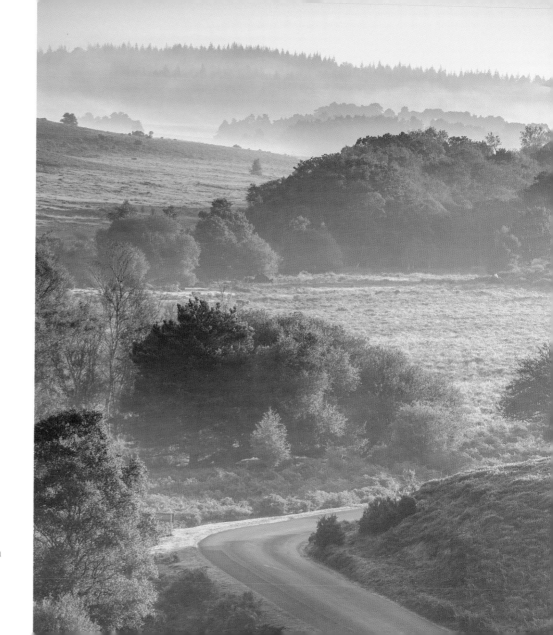

Rockford Common

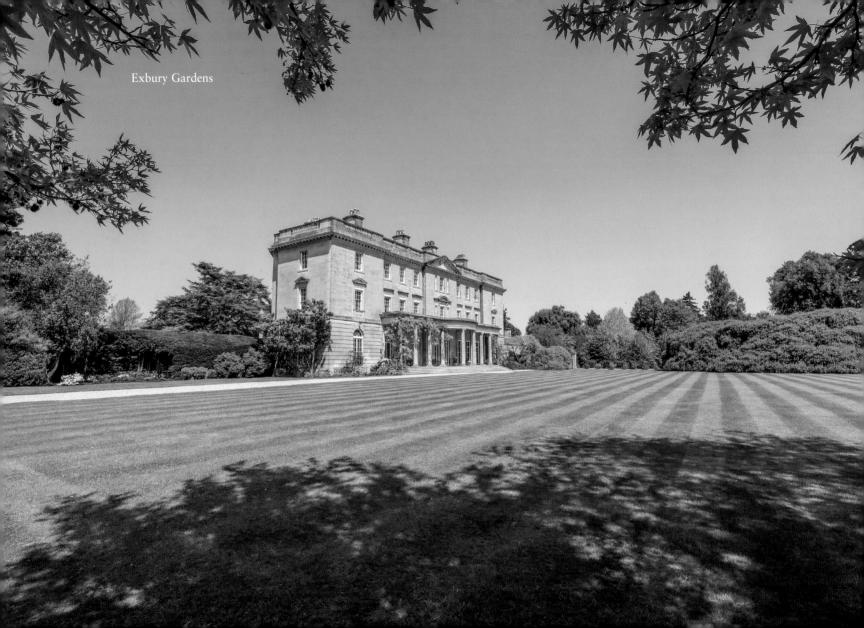

Exbury Gardens

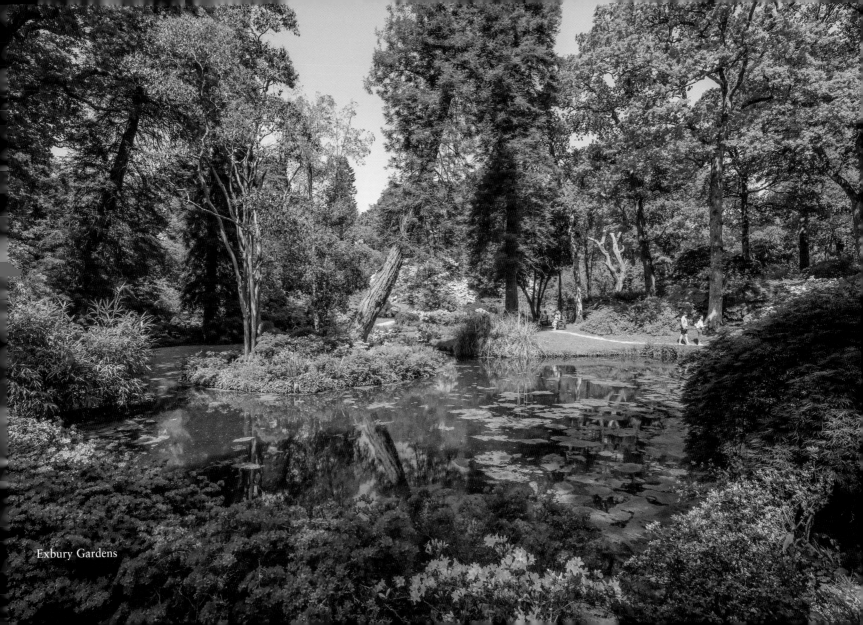

Exbury Gardens

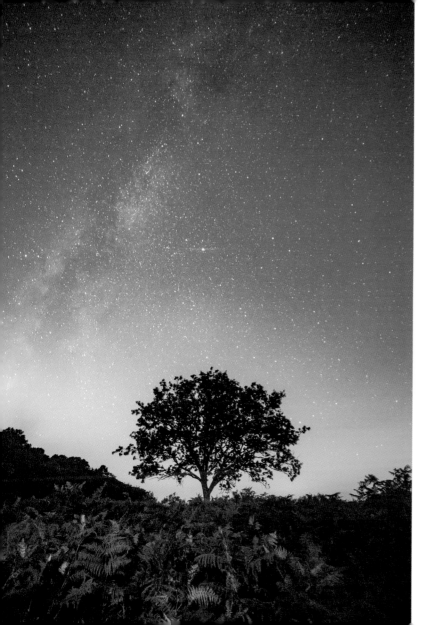

Lonely Tree, New Forest

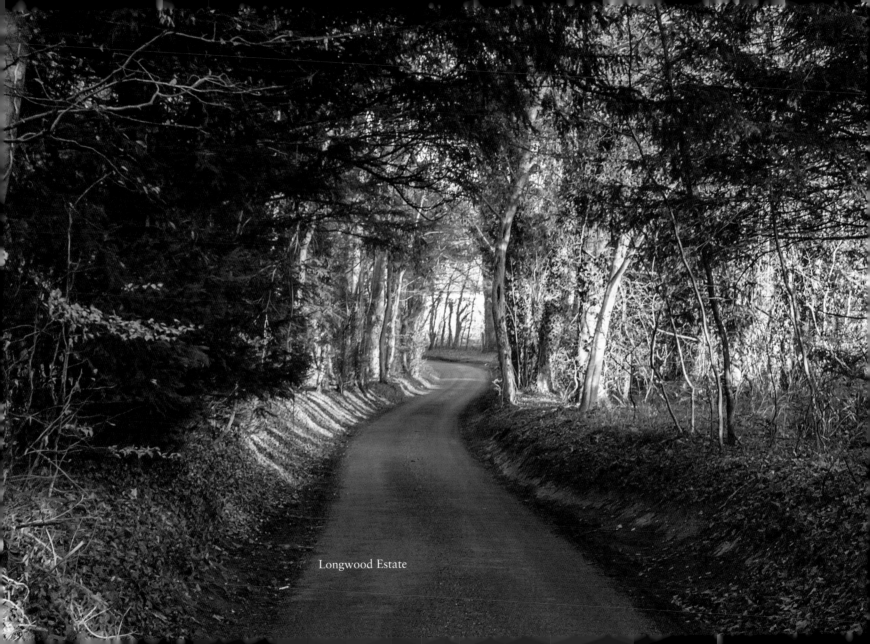
Longwood Estate

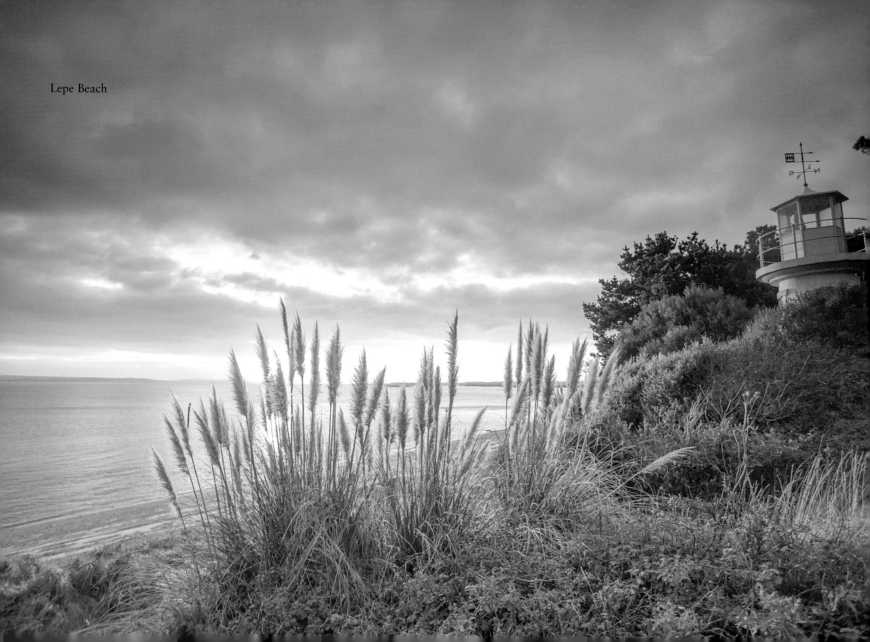

Lepe Beach

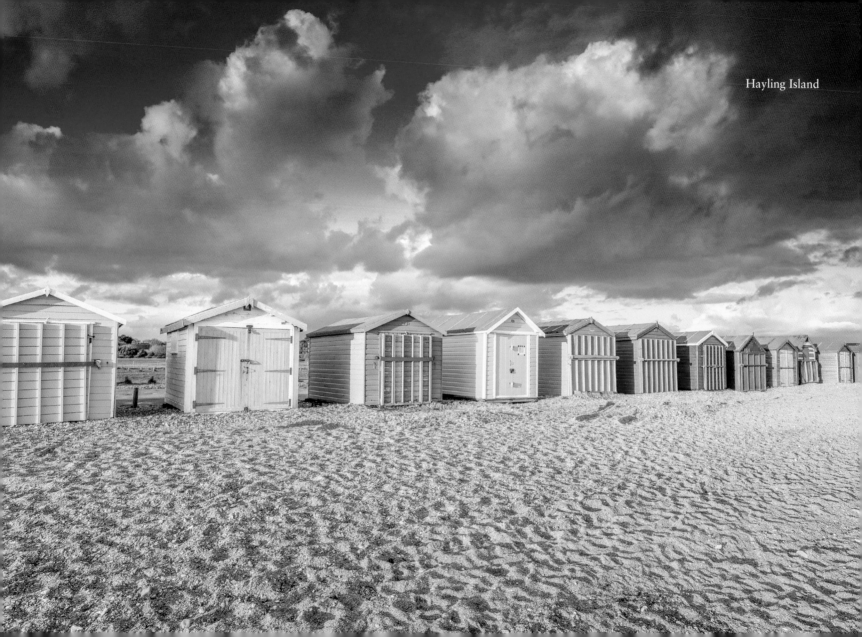

Hayling Island

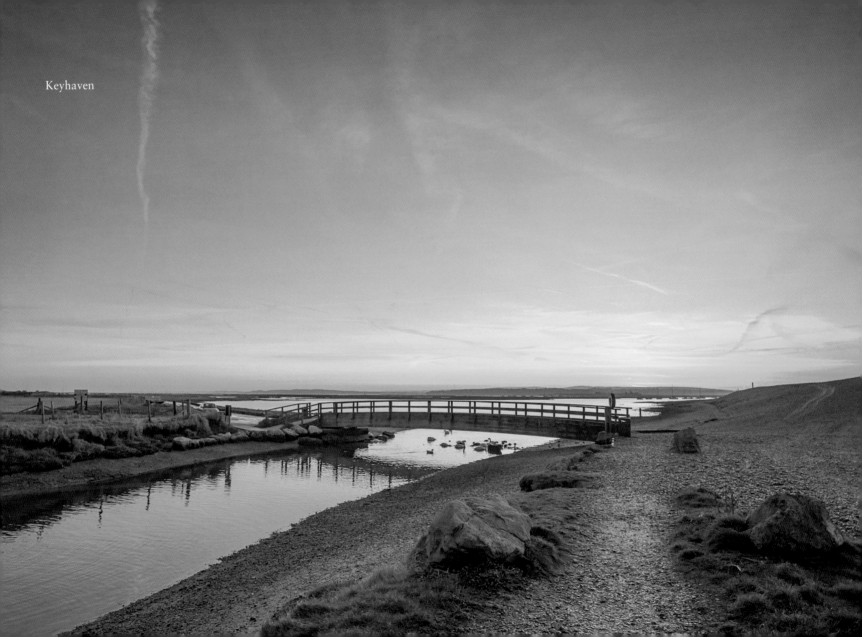

Keyhaven

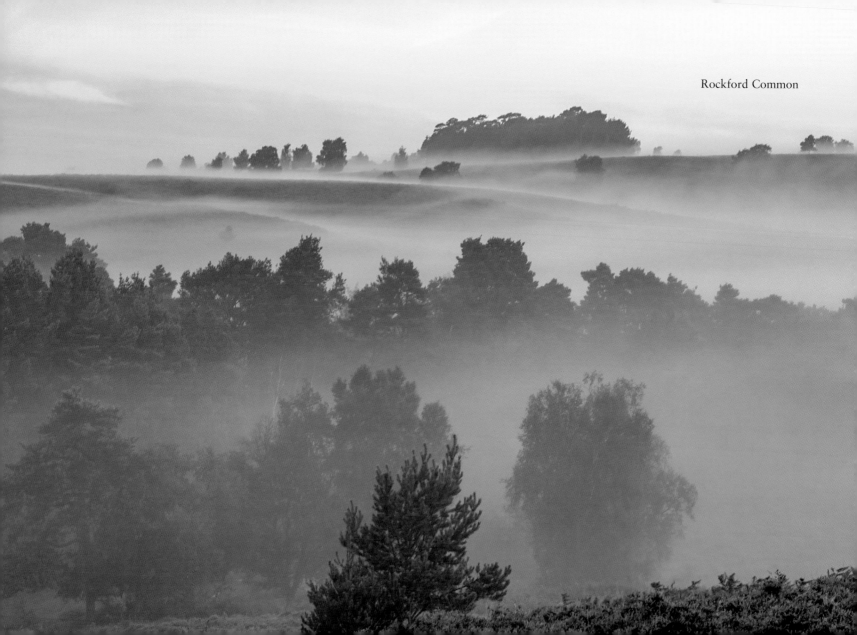

Rockford Common

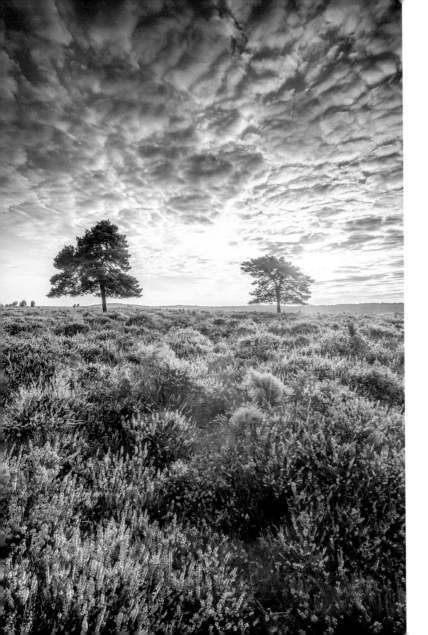

Lonely Tree, New Forest

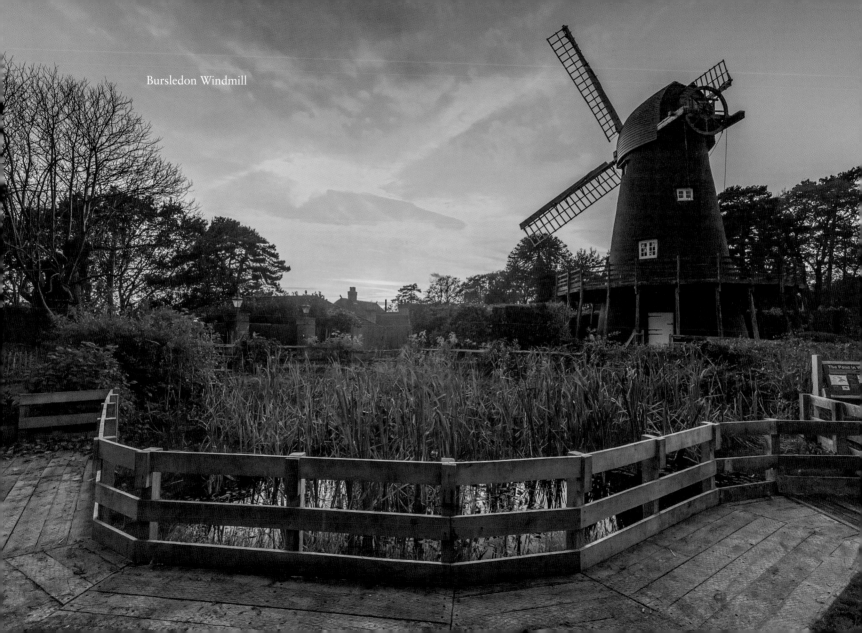

Bursledon Windmill

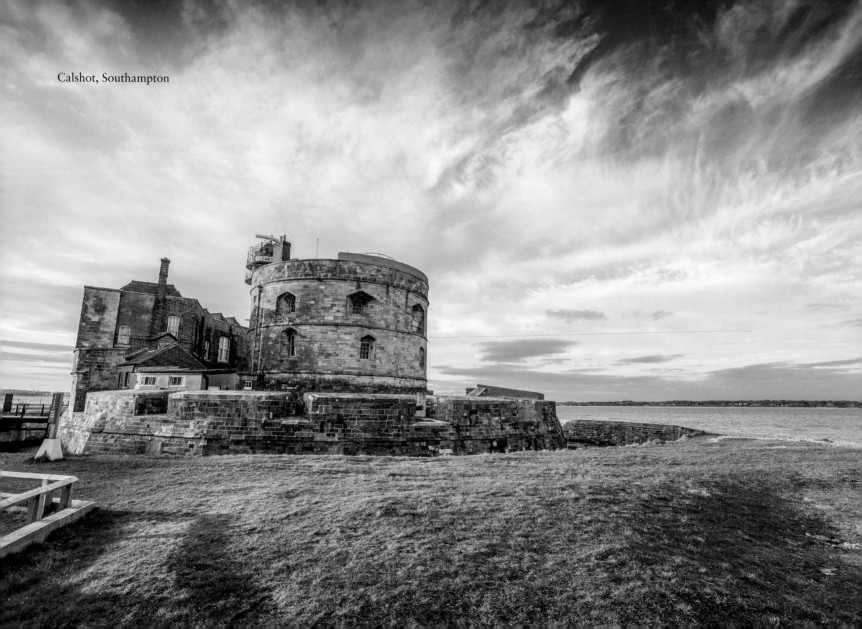

Calshot, Southampton

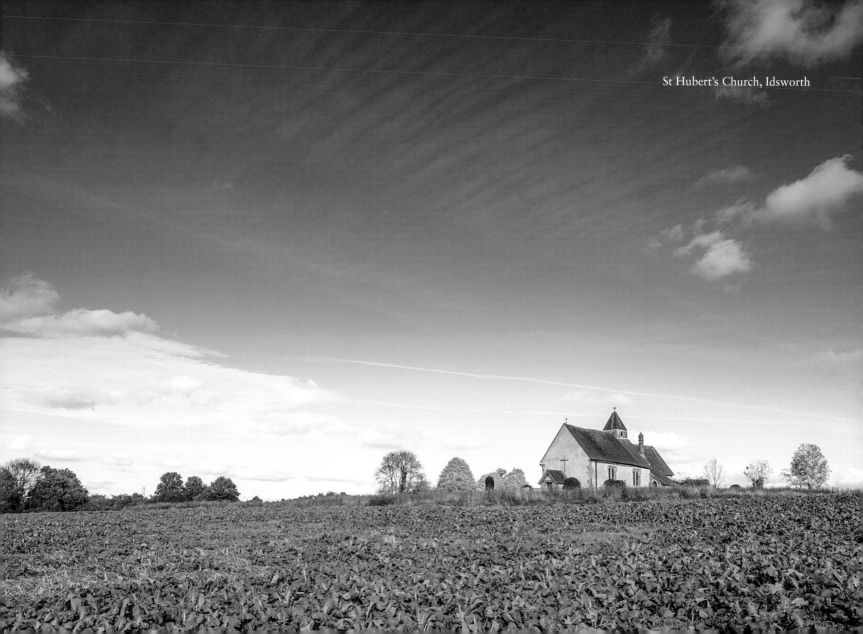
St Hubert's Church, Idsworth

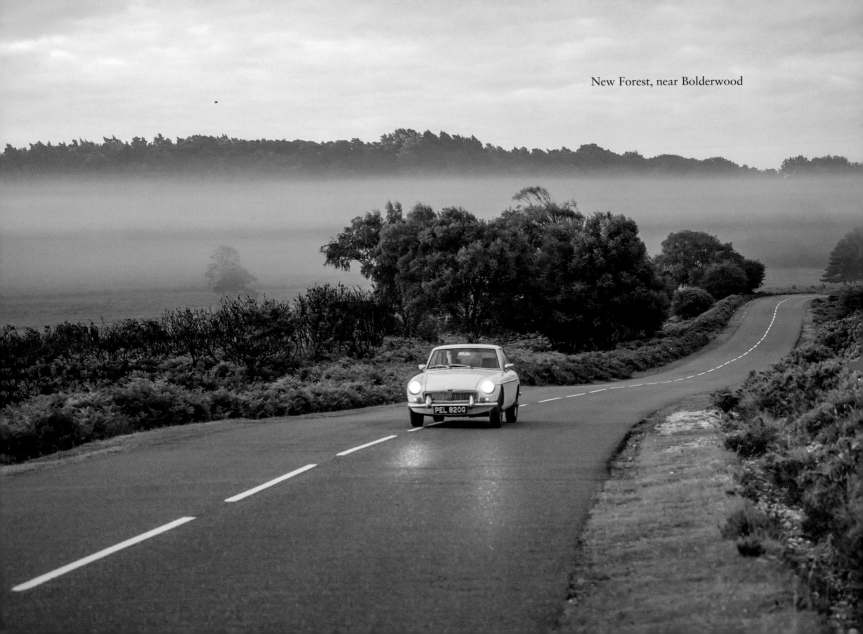

New Forest, near Bolderwood

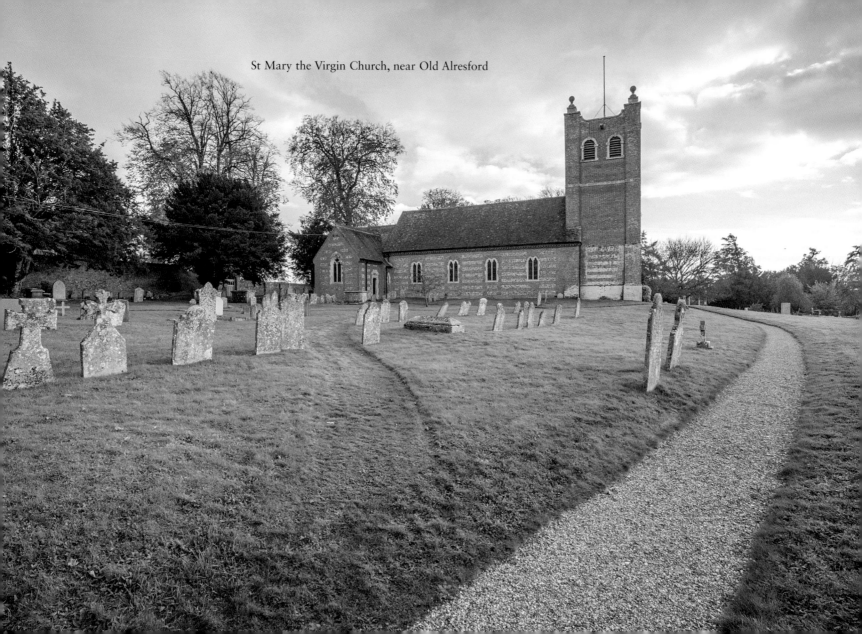

St Mary the Virgin Church, near Old Alresford

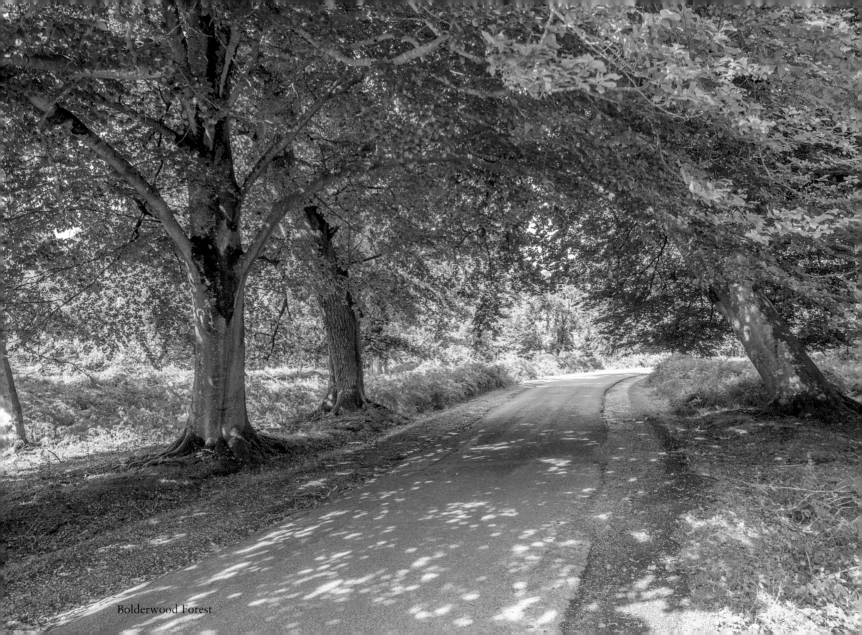

Bolderwood Forest

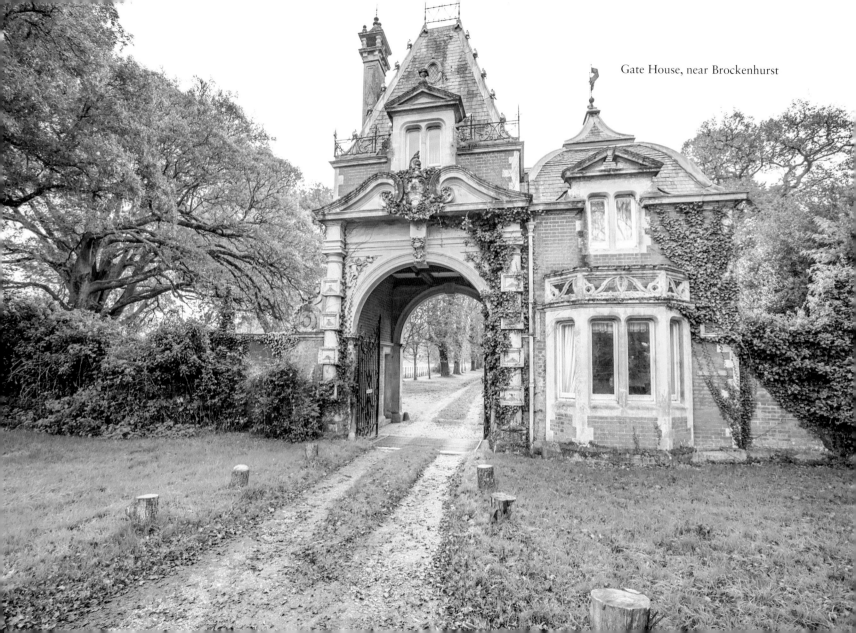

Gate House, near Brockenhurst

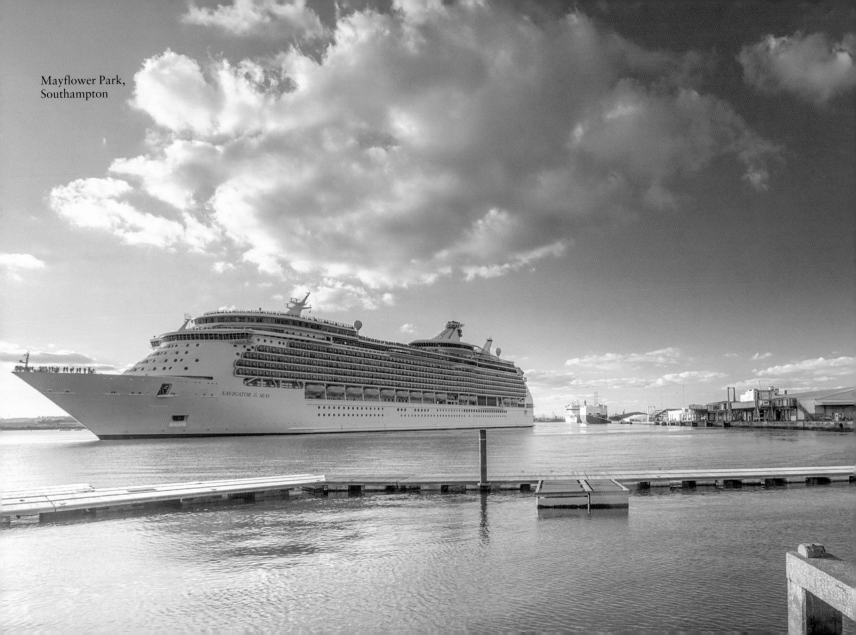

Mayflower Park,
Southampton

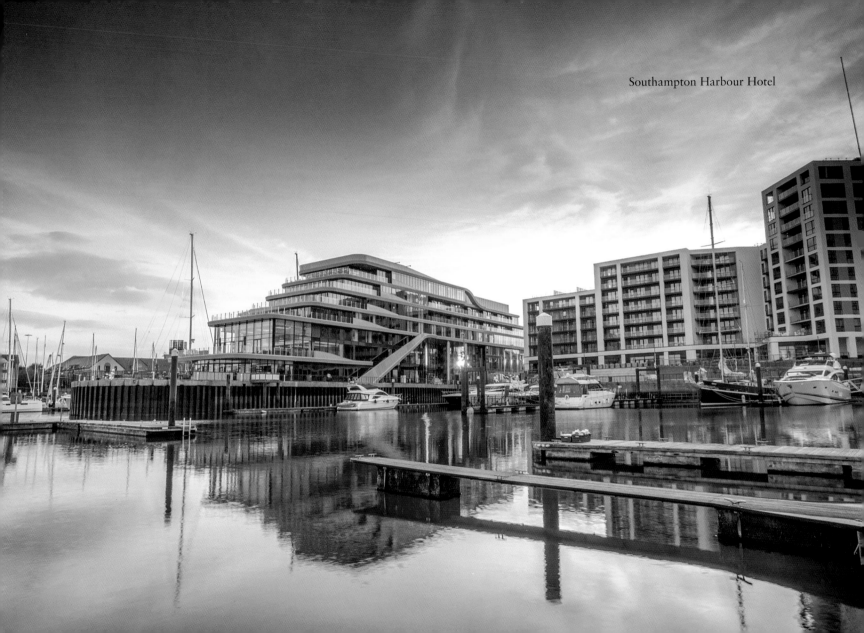

Southampton Harbour Hotel

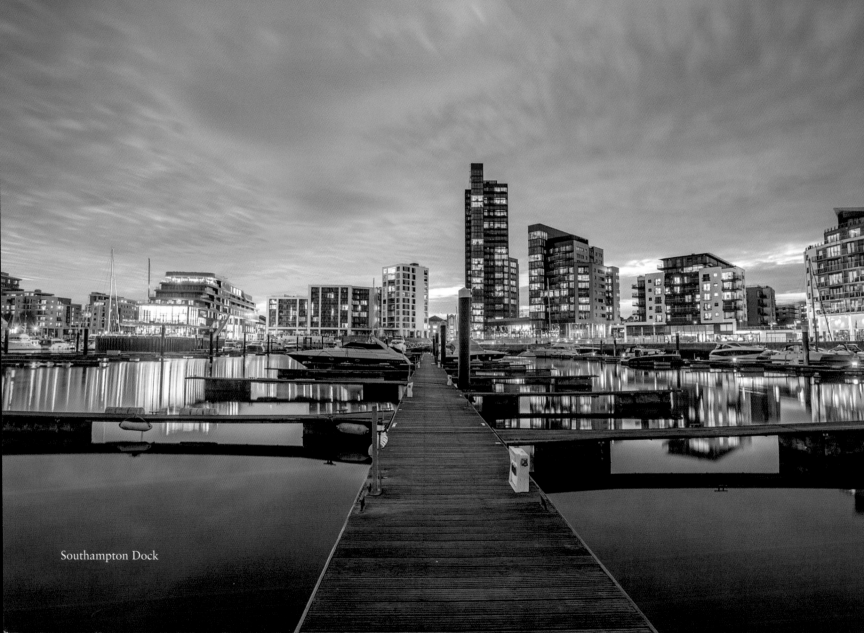

Southampton Dock

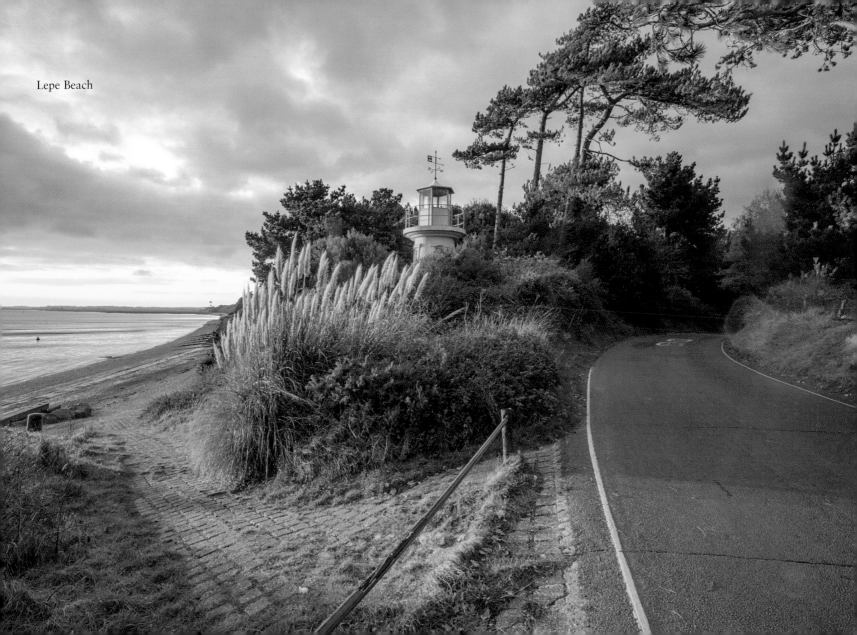

Lepe Beach

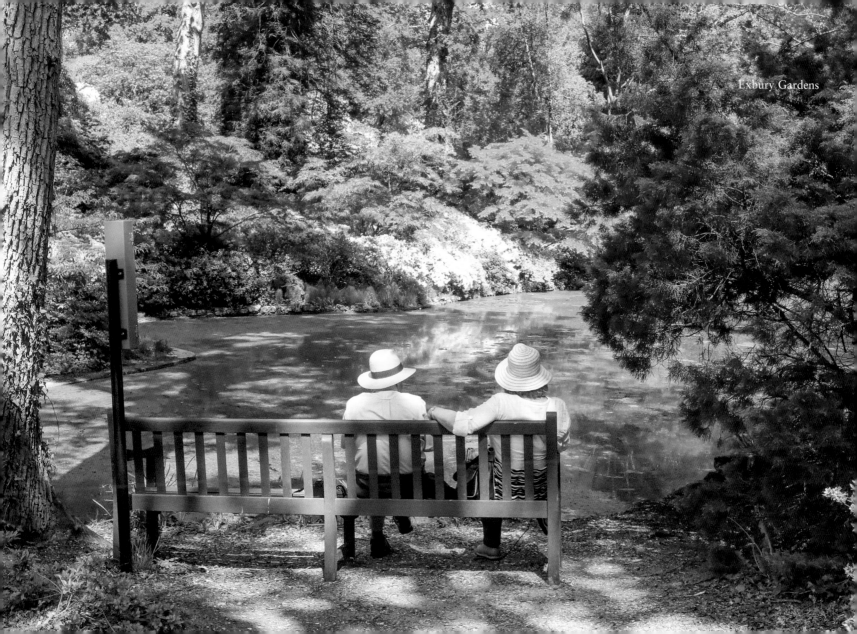

Exbury Gardens

AUTUMN

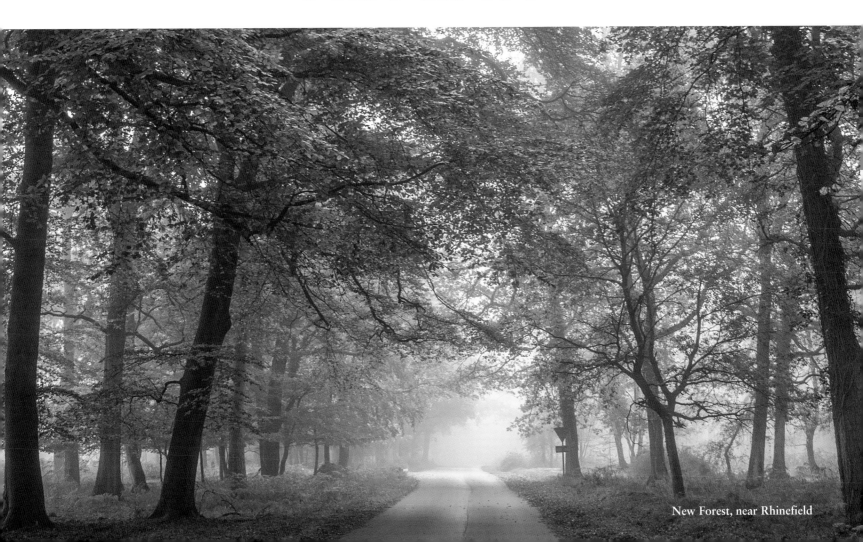

New Forest, near Rhinefield

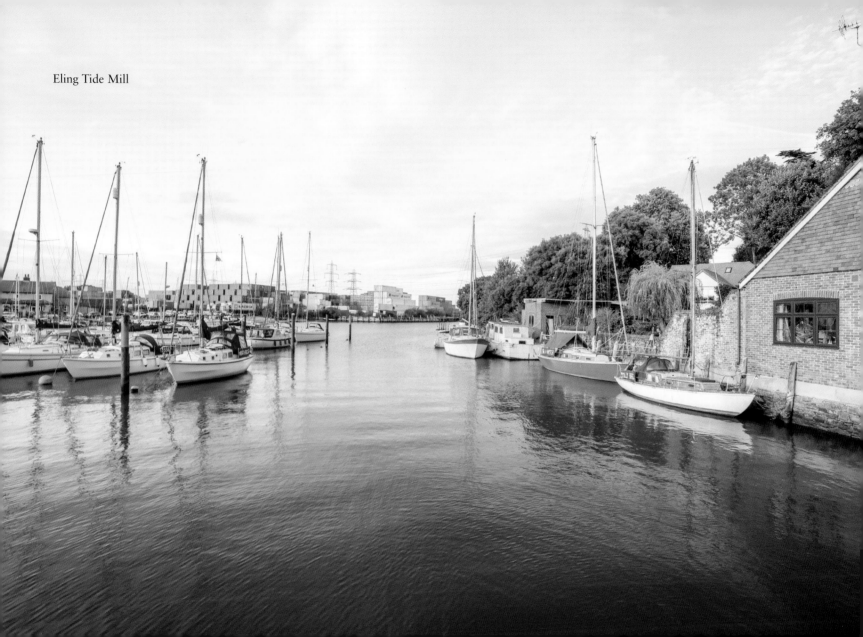

Eling Tide Mill

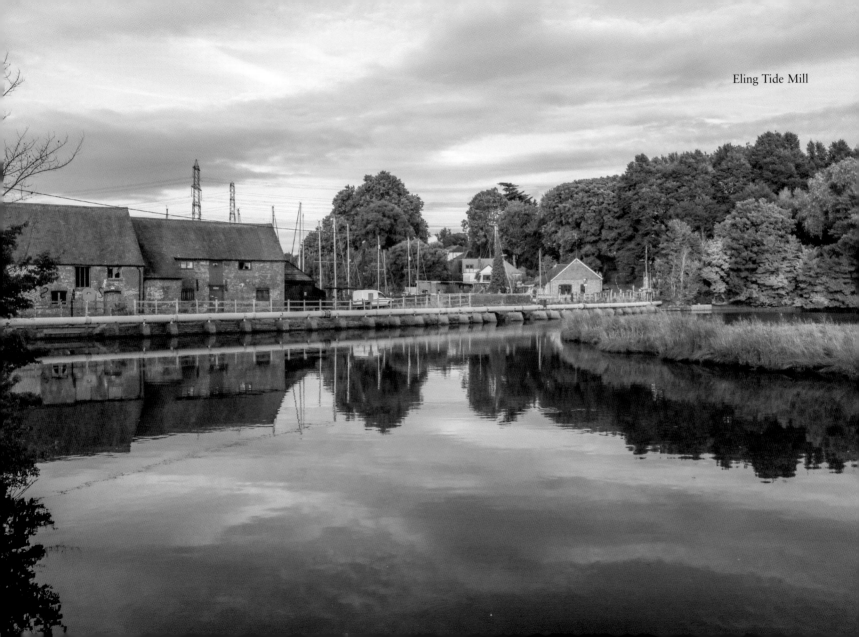

Eling Tide Mill

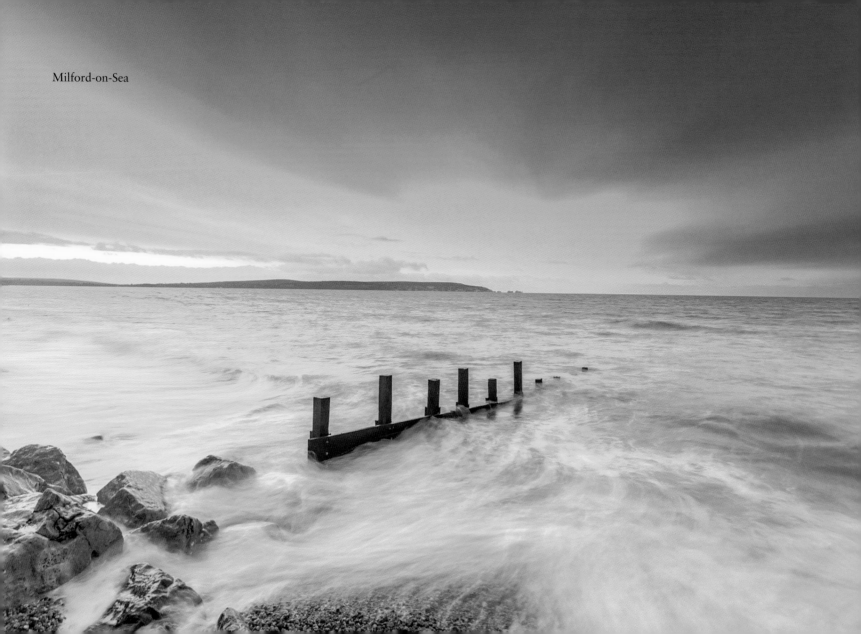

Milford-on-Sea

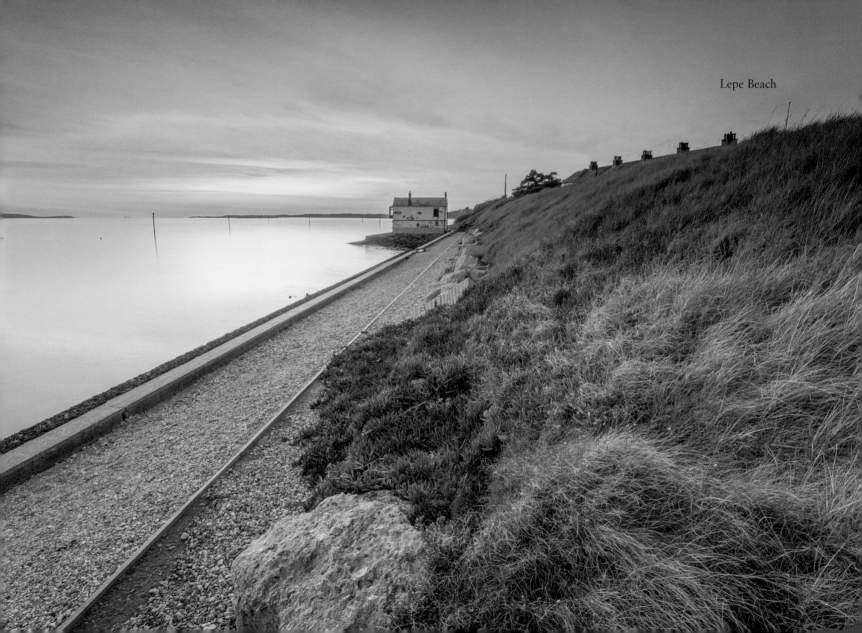

Lepe Beach

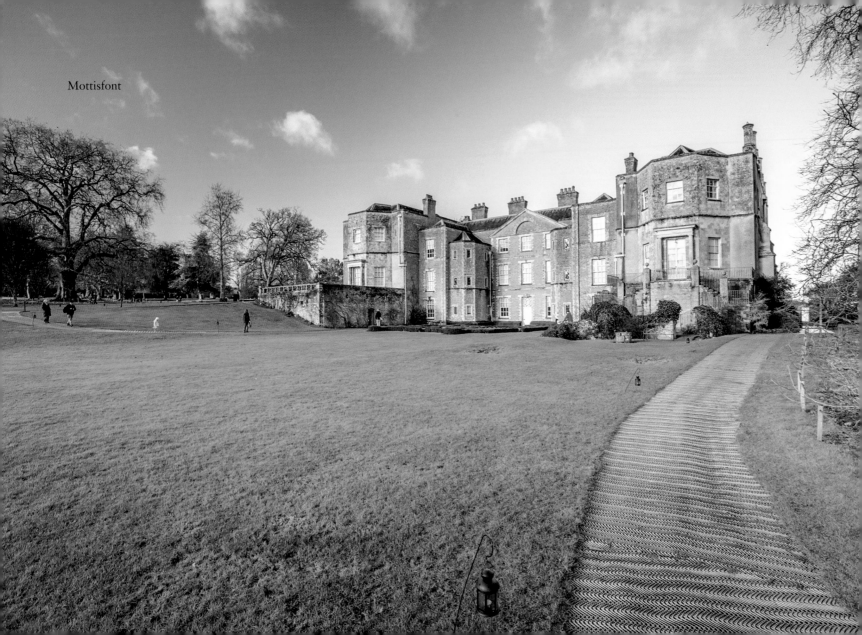

Mottisfont

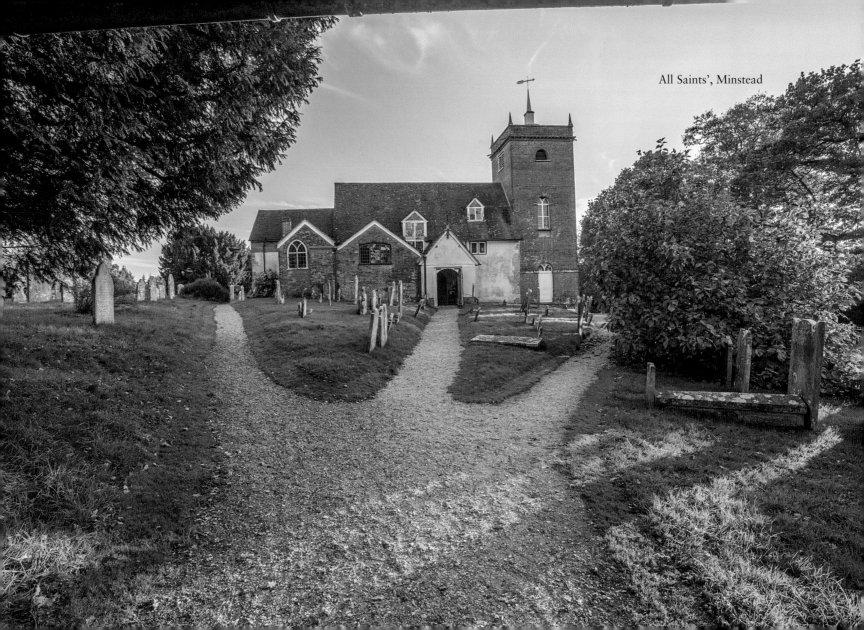

All Saints', Minstead

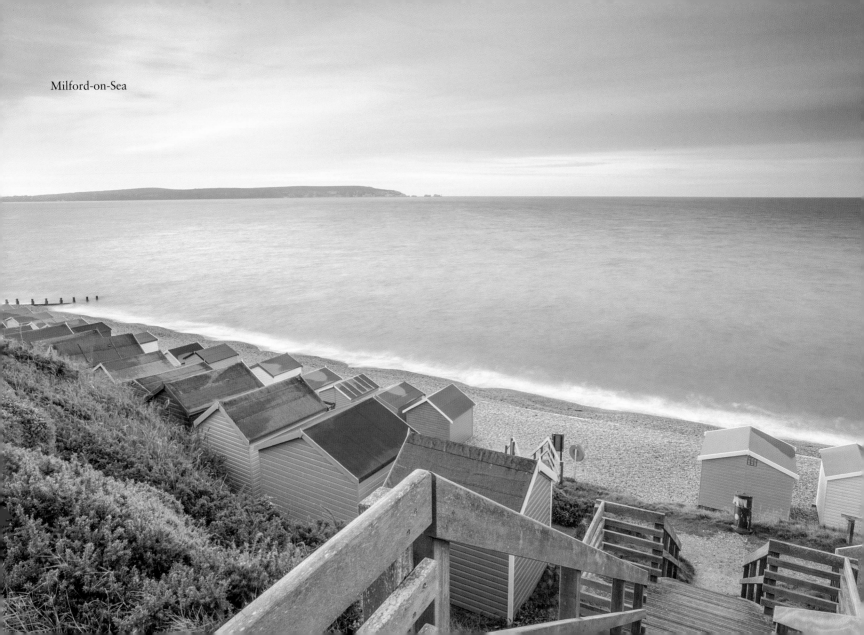

Milford-on-Sea

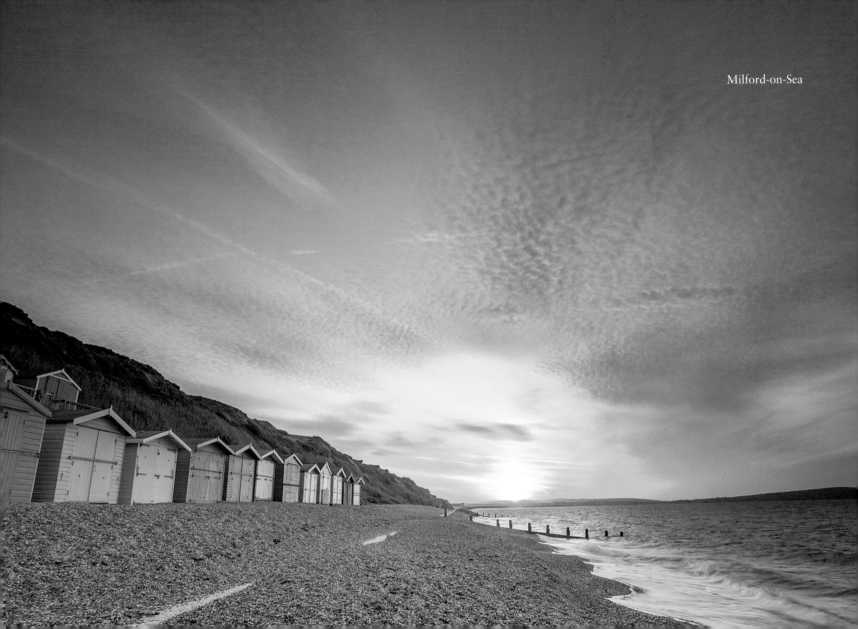

Milford-on-Sea

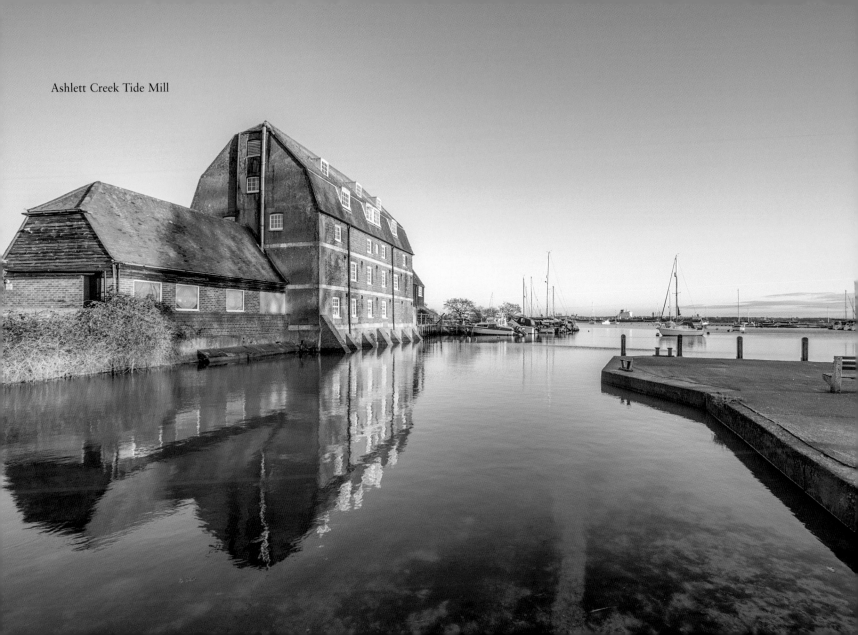
Ashlett Creek Tide Mill

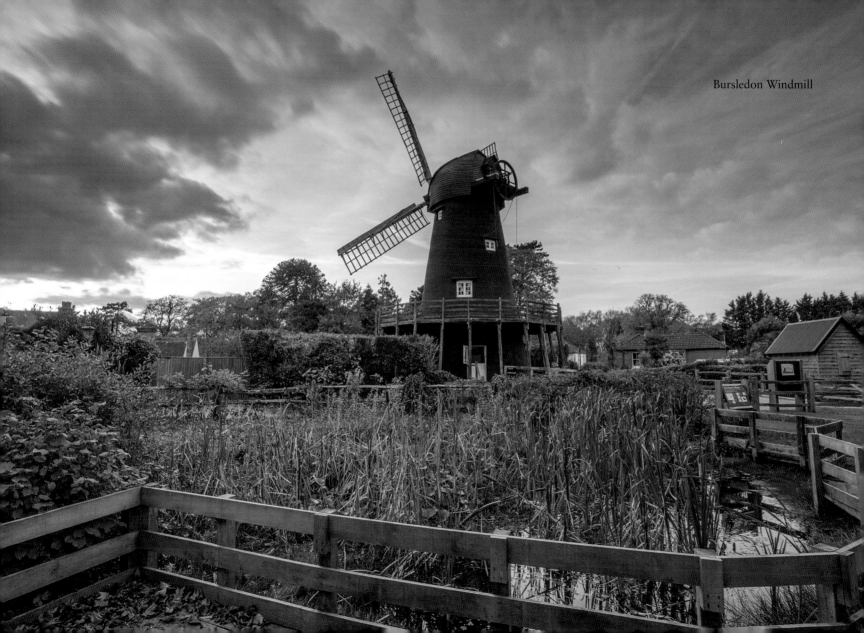

Bursledon Windmill

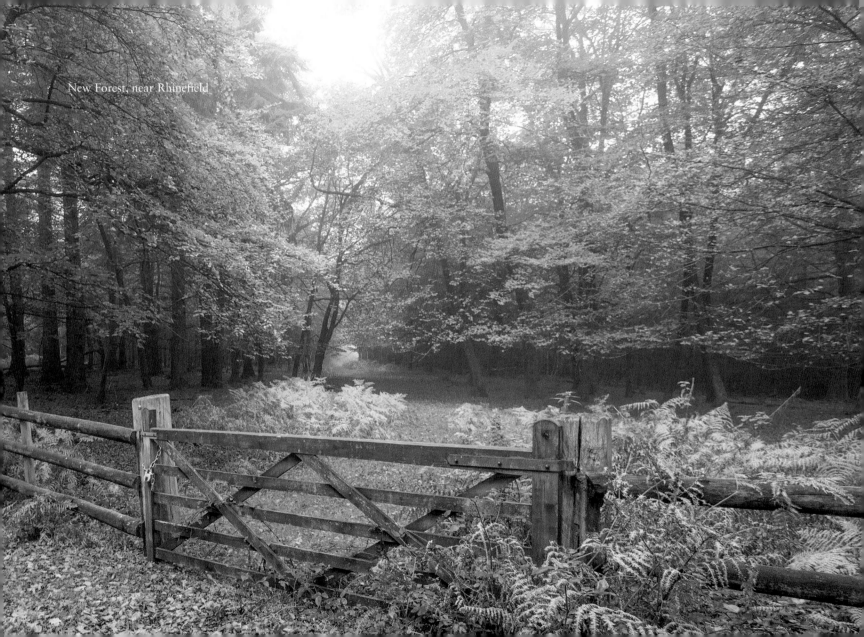

New Forest, near Rhinefield

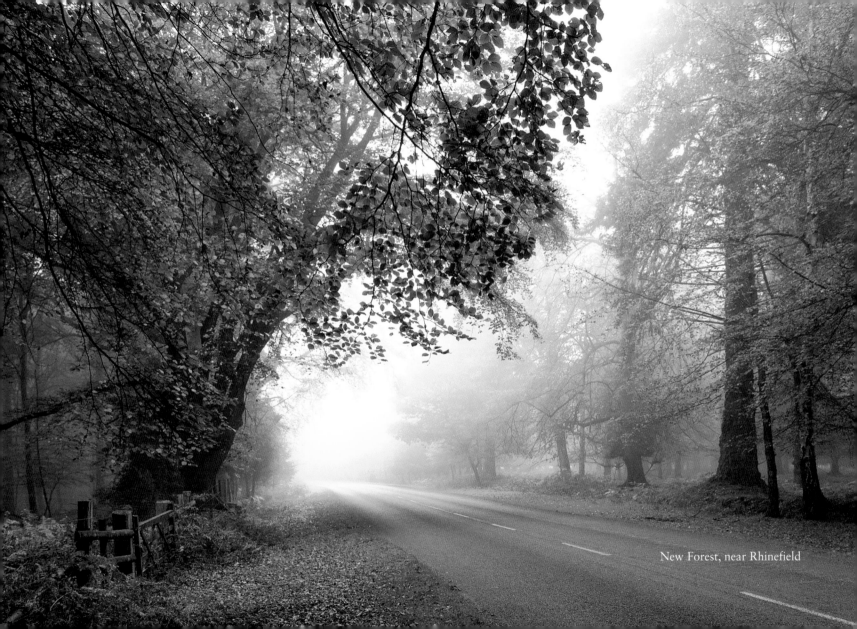

New Forest, near Rhinefield

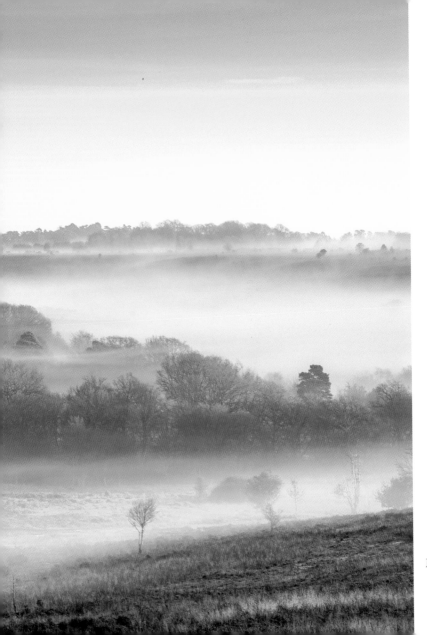

Mogshade Pond

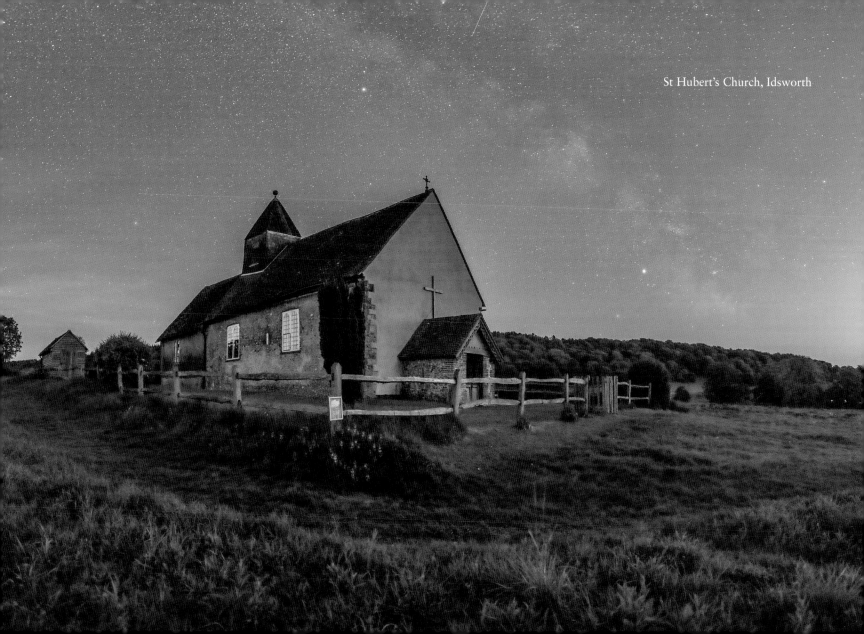

St Hubert's Church, Idsworth

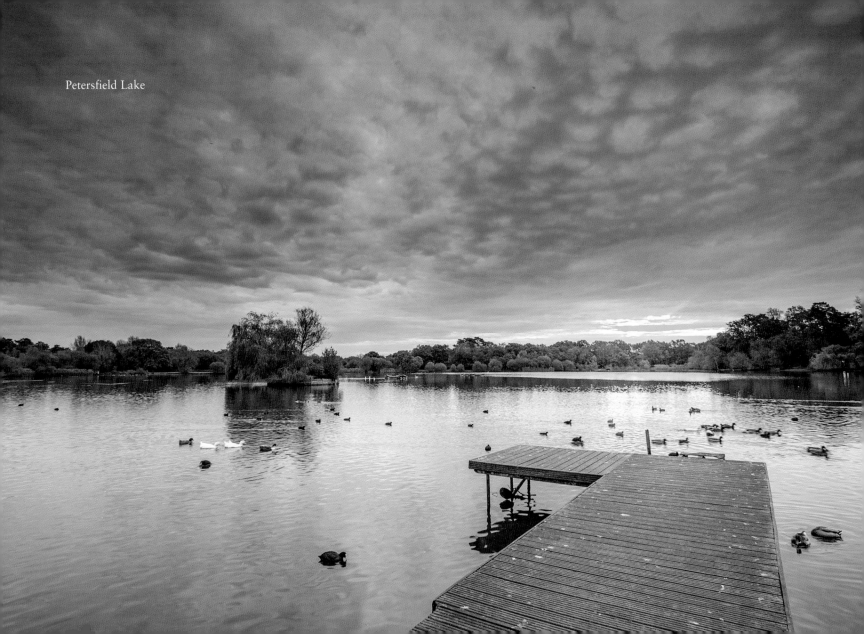

Petersfield Lake

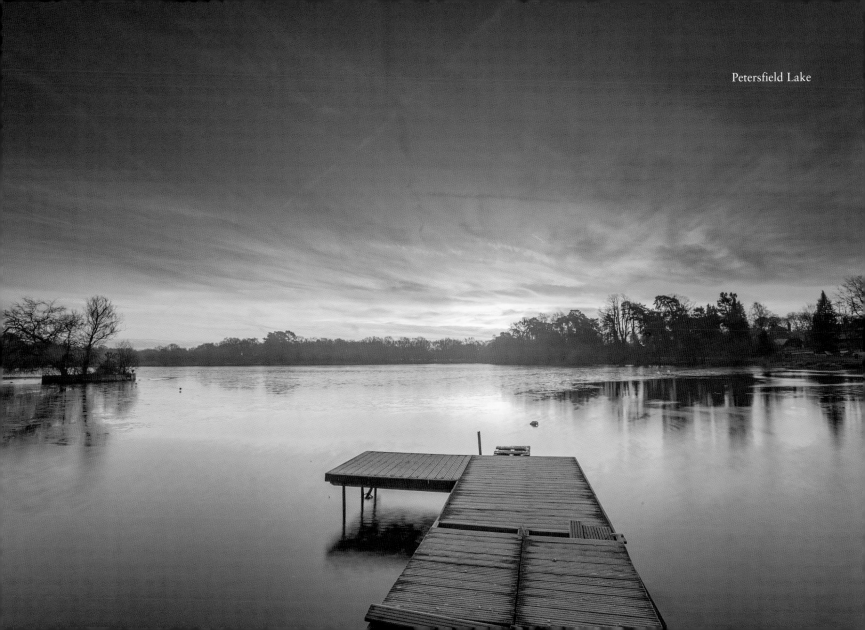

Petersfield Lake

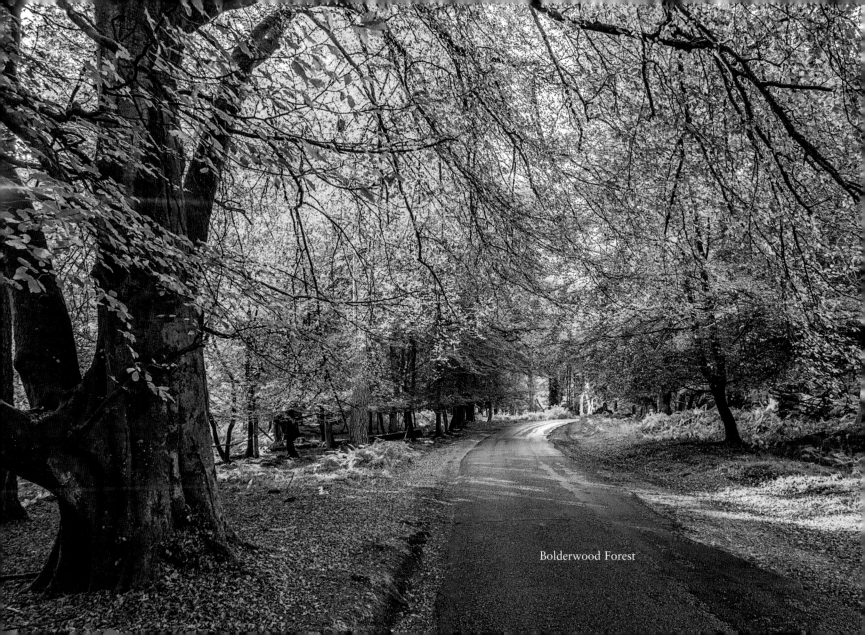

Bolderwood Forest

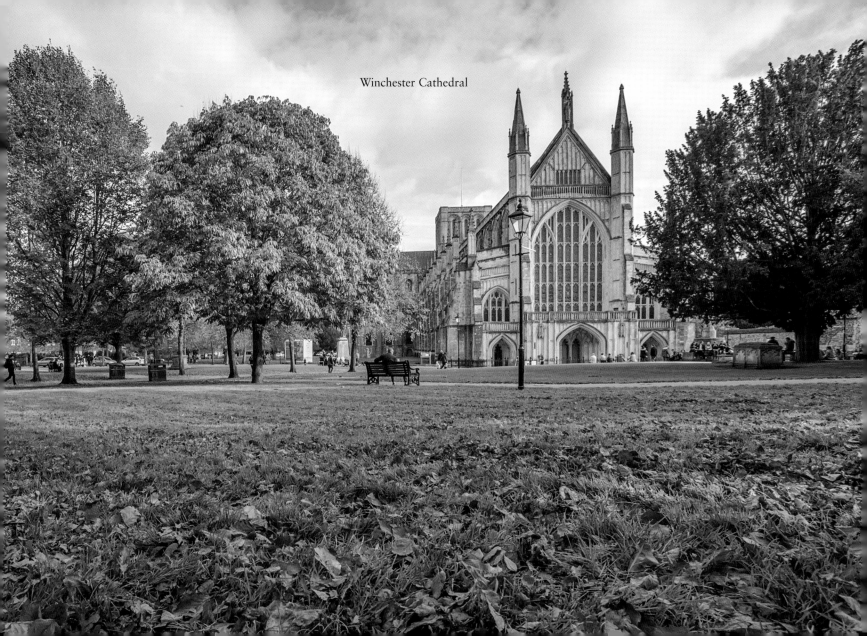
Winchester Cathedral

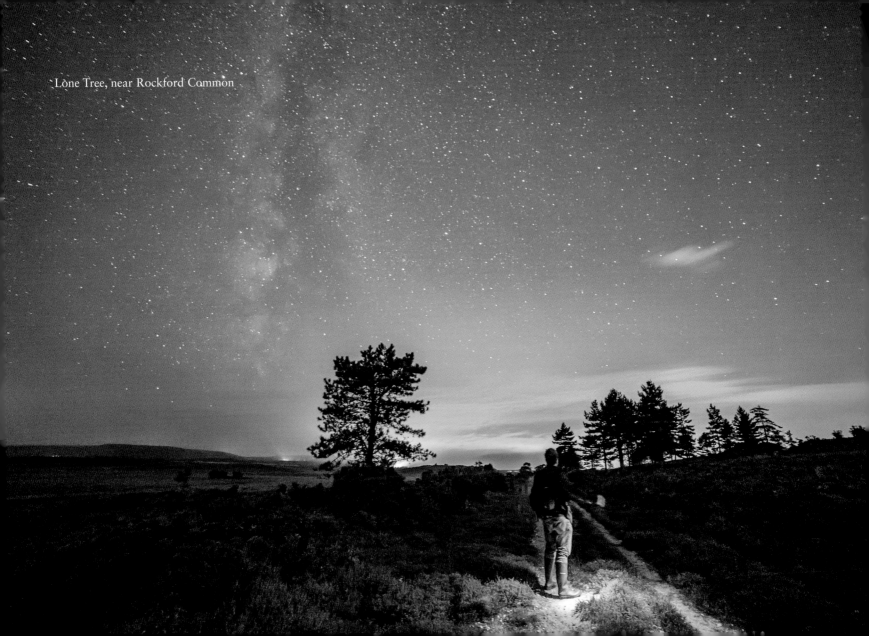

Lòne Tree, near Rockford Common

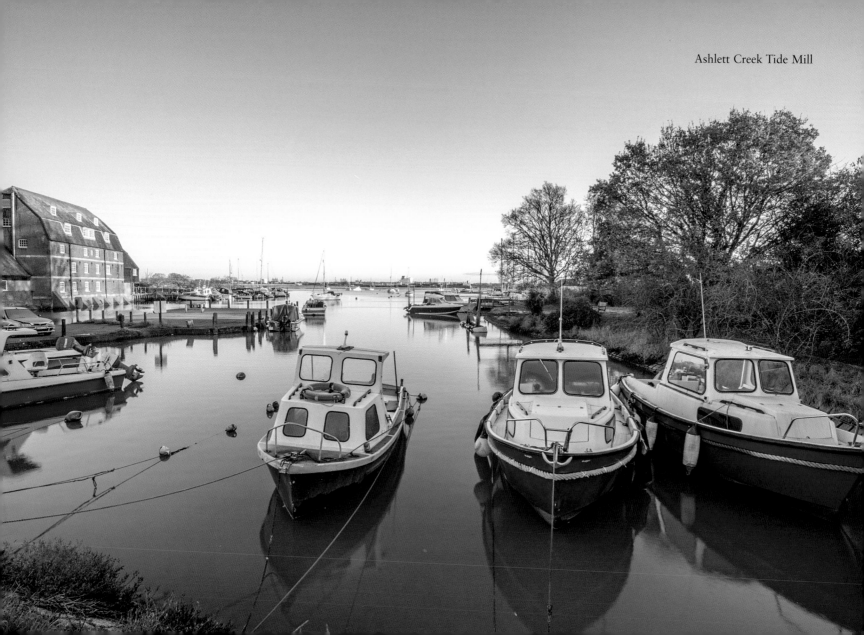

Ashlett Creek Tide Mill

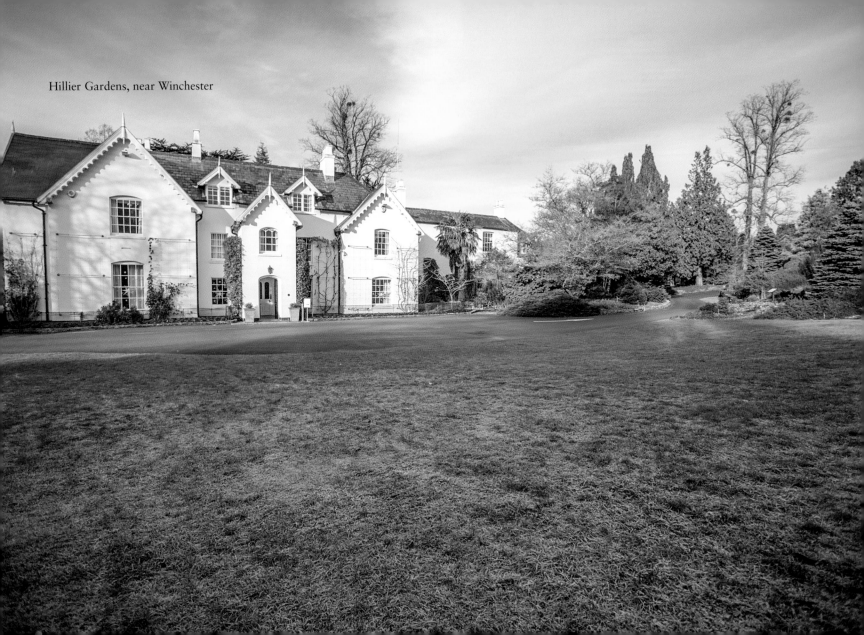

Hillier Gardens, near Winchester

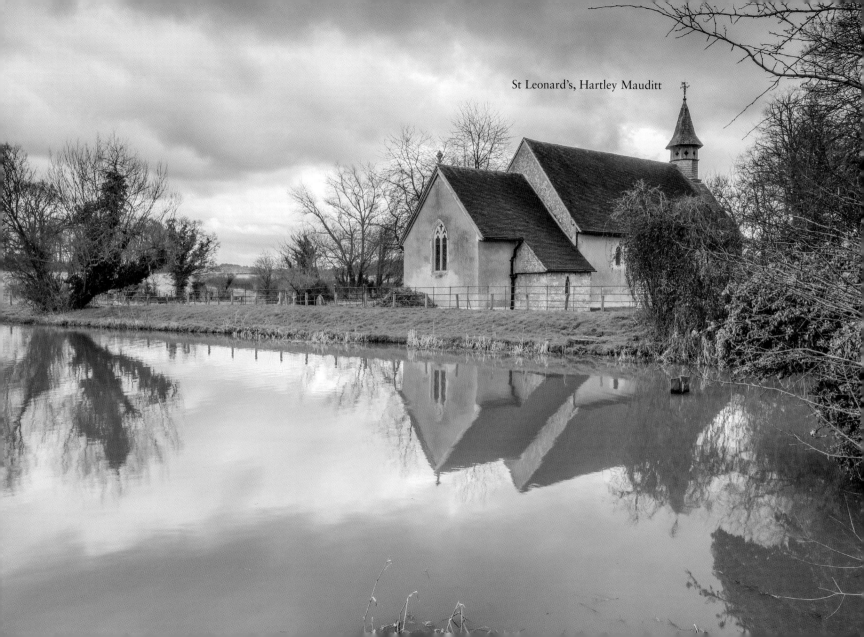

St Leonard's, Hartley Mauditt

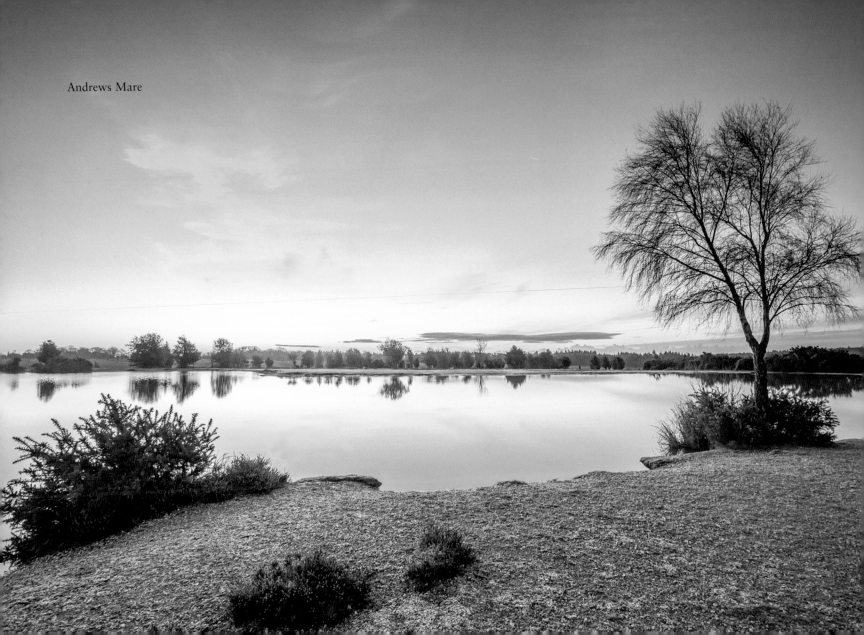

Andrews Mare

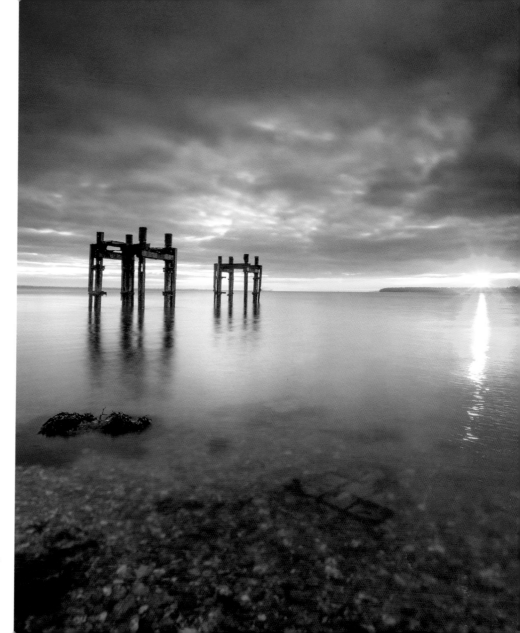

Lepe Beach

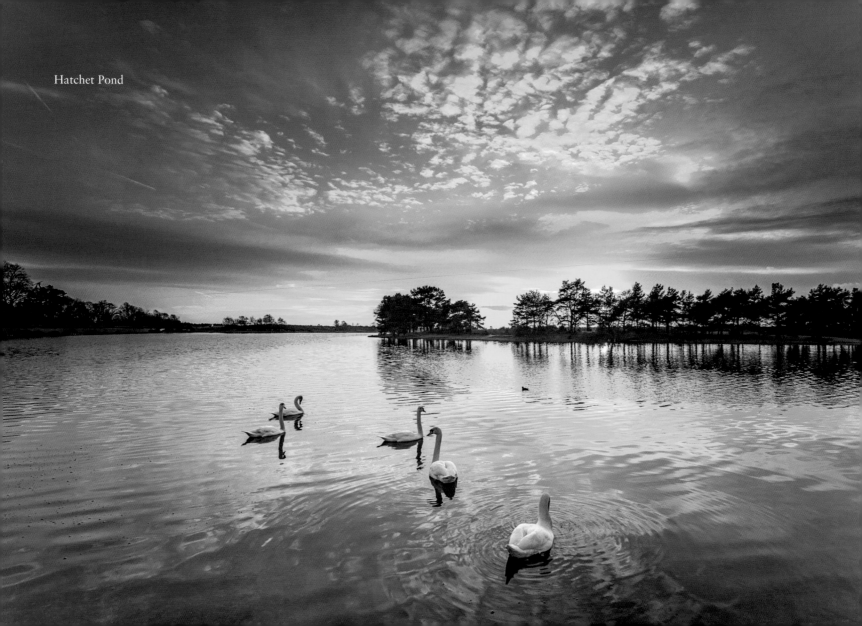

Hatchet Pond

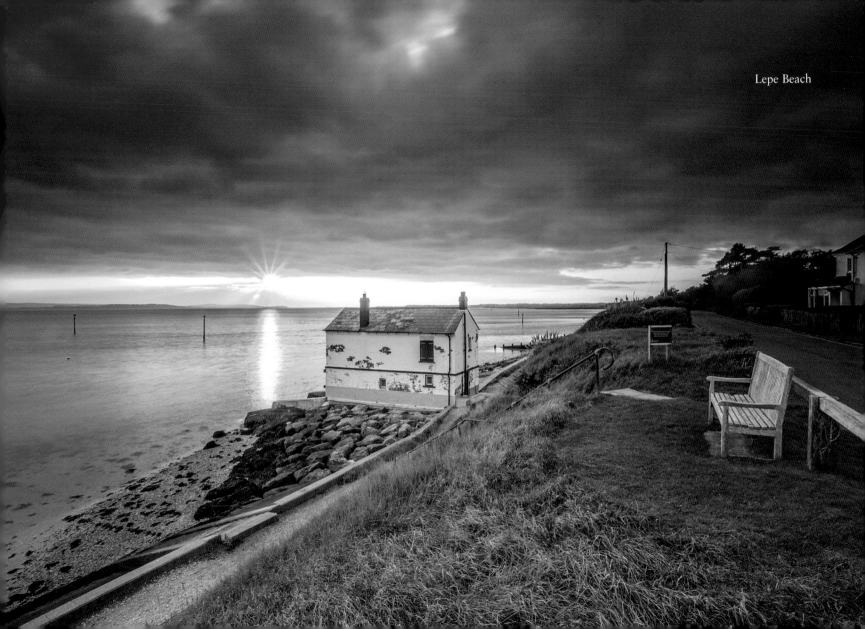

Lepe Beach

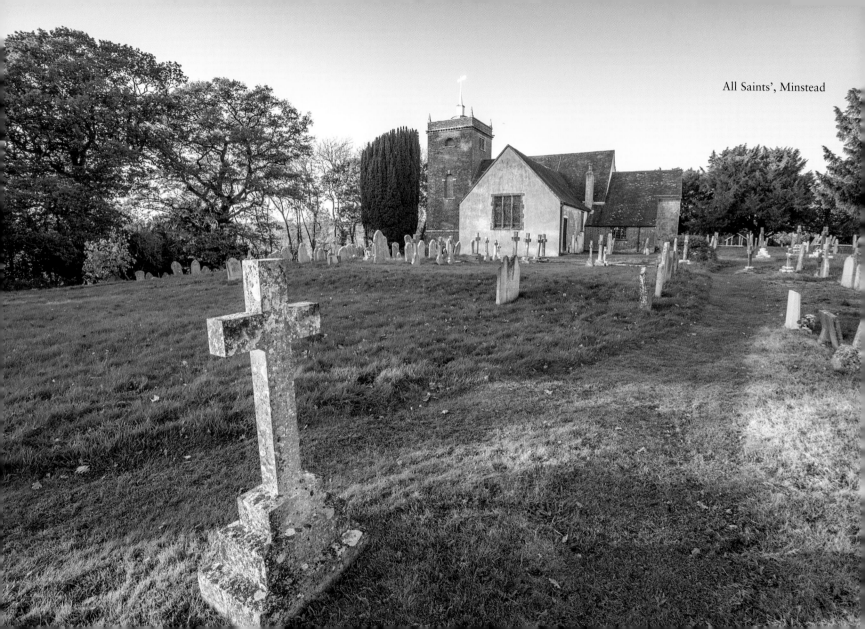

All Saints', Minstead

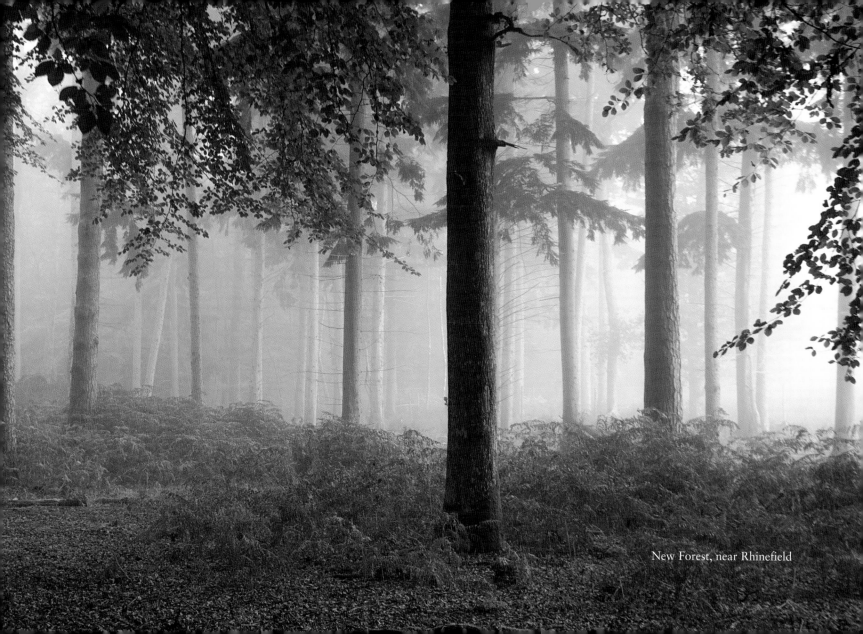

New Forest, near Rhinefield

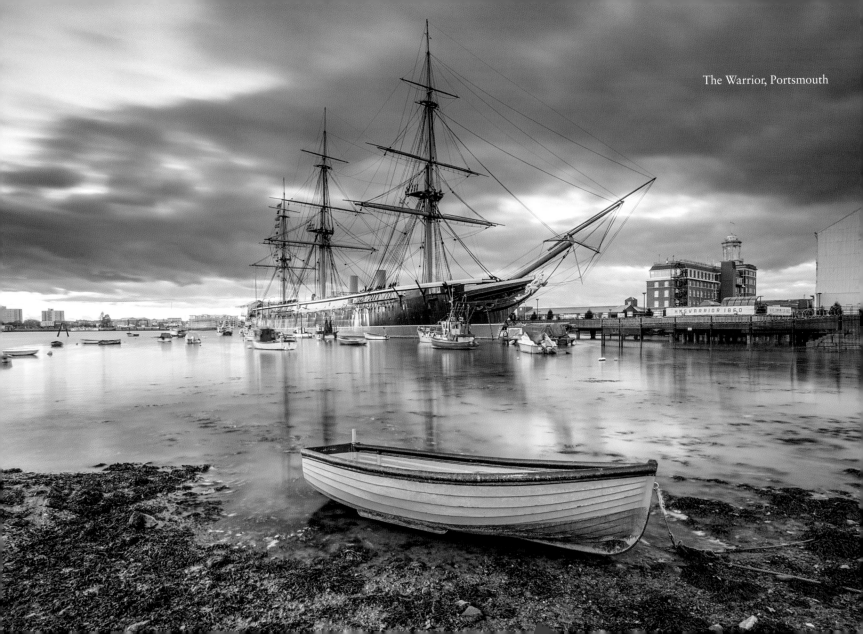

The Warrior, Portsmouth

WINTER

Rhinefield House

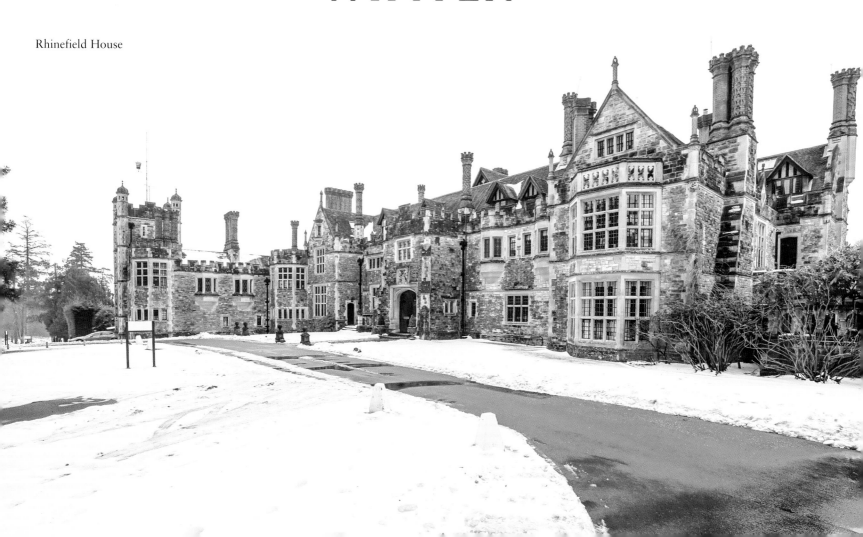

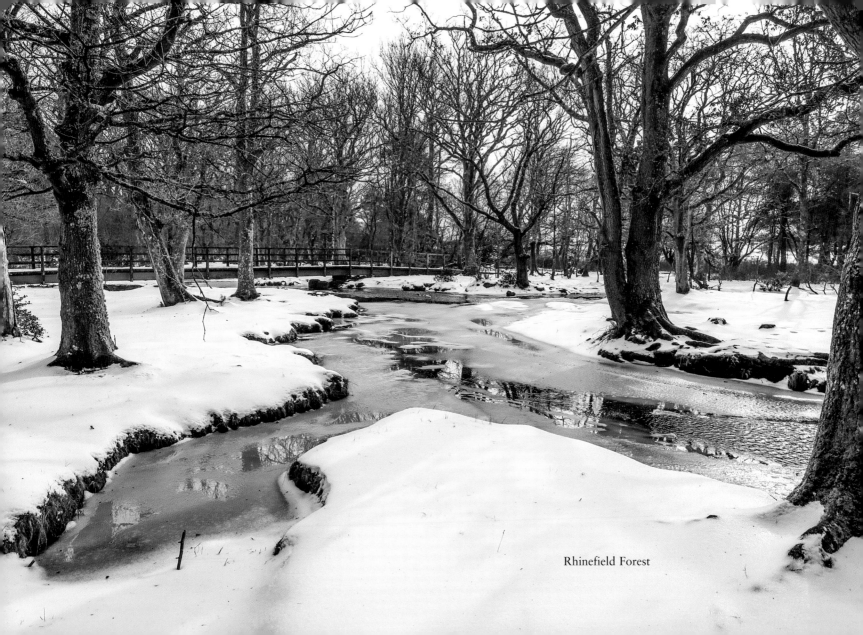

Rhinefield Forest

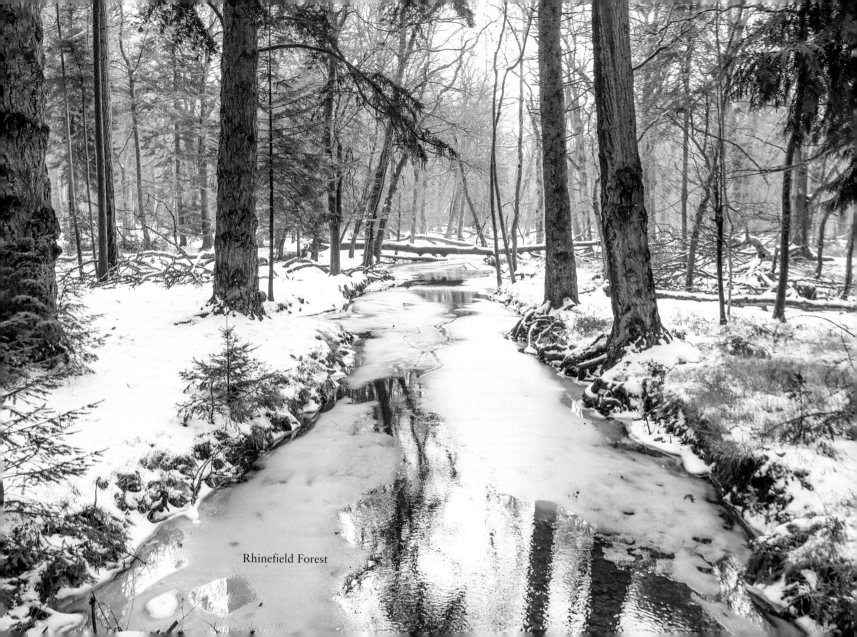

Rhinefield Forest

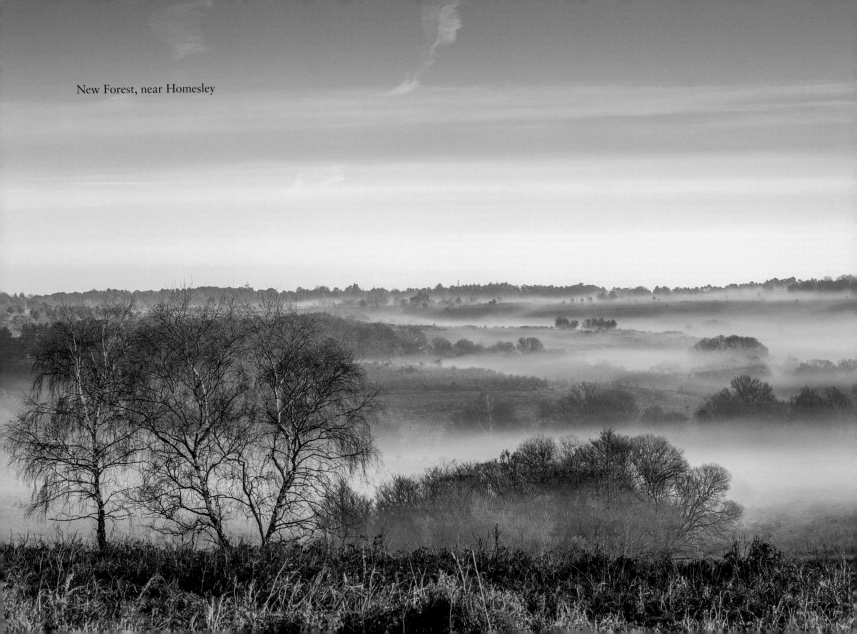

New Forest, near Homesley

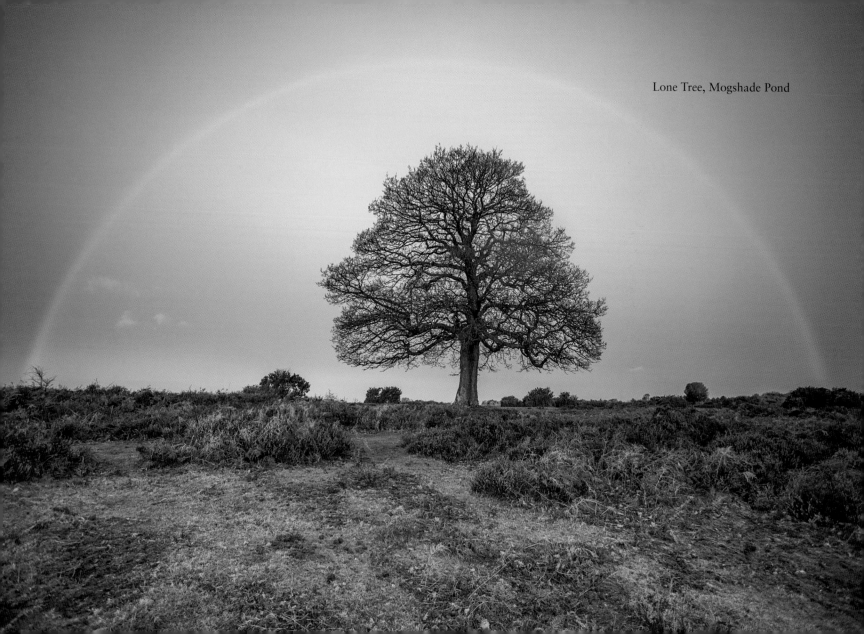

Lone Tree, Mogshade Pond

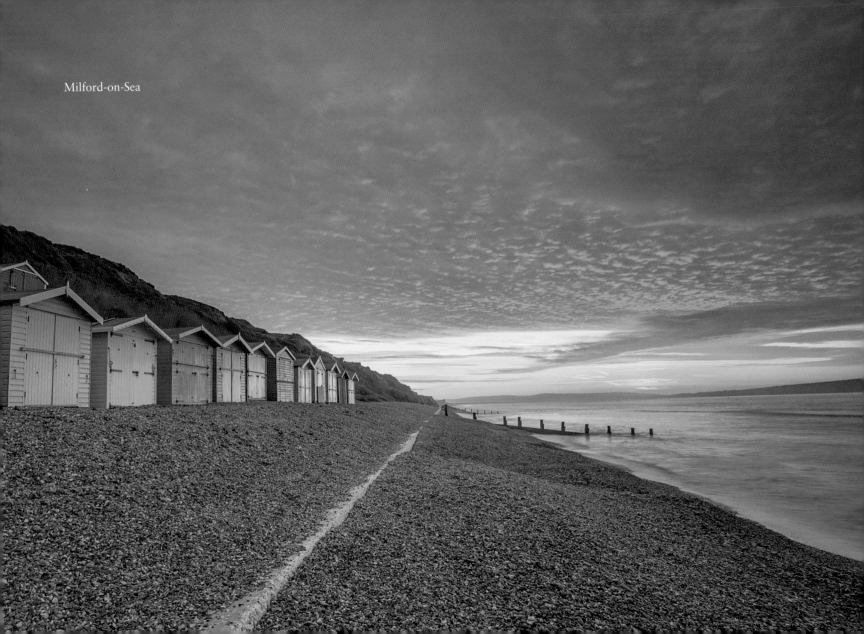
Milford-on-Sea

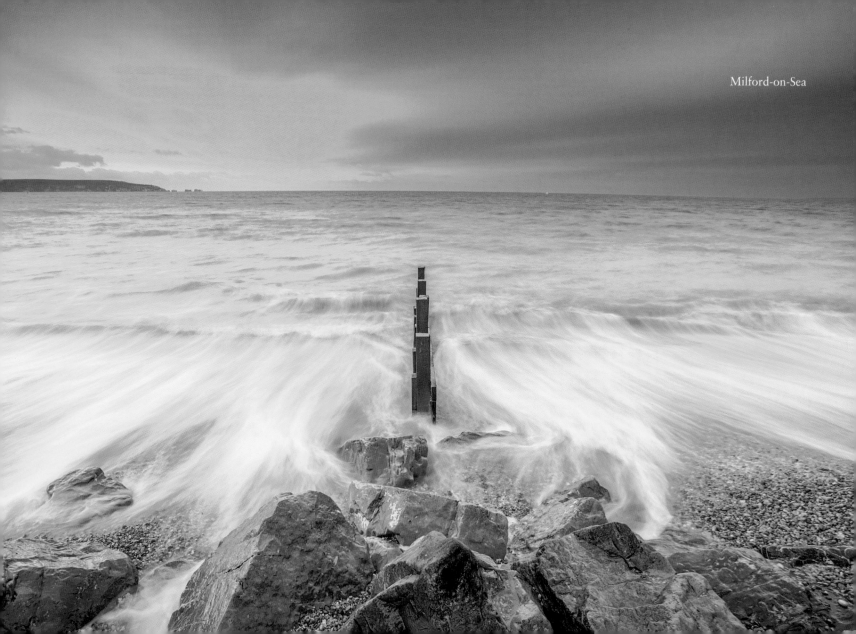

Milford-on-Sea

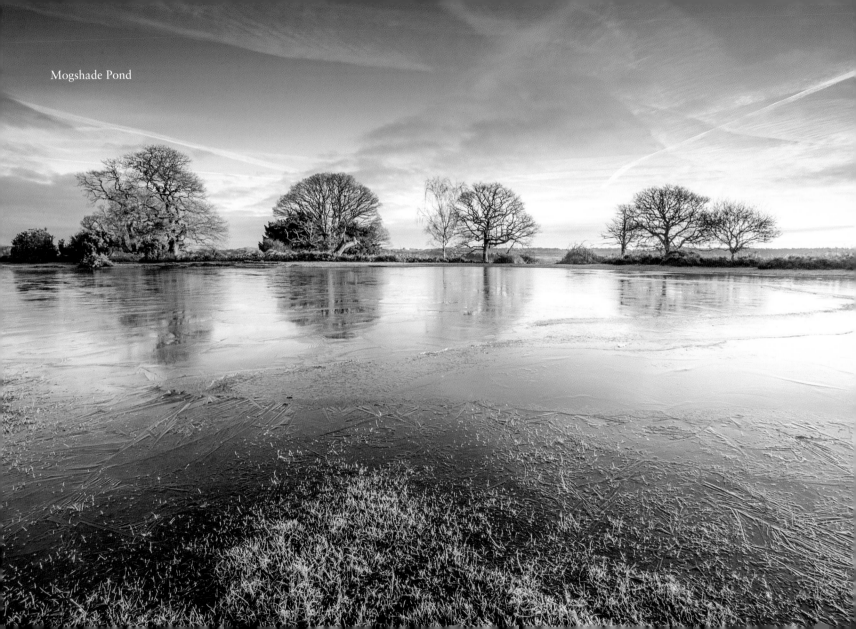

Mogshade Pond

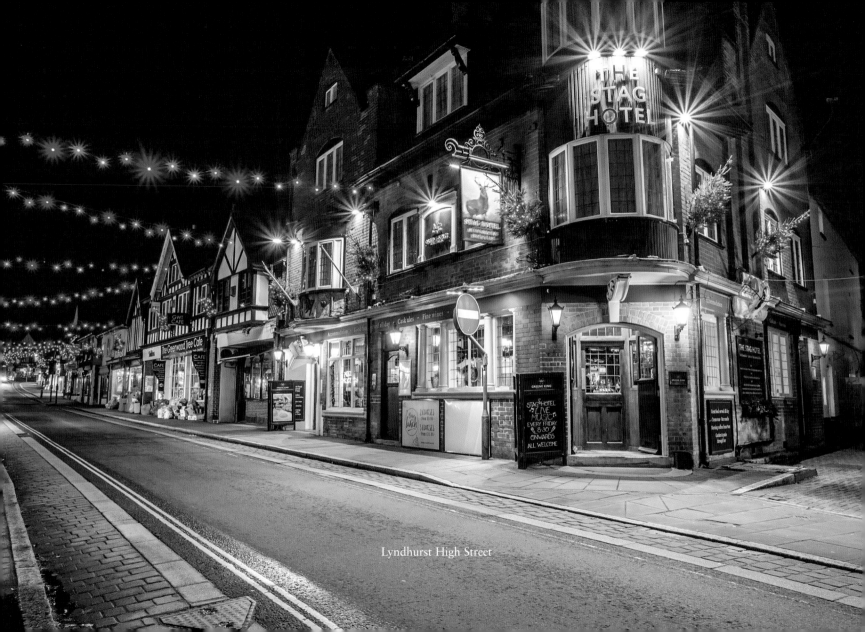

Lyndhurst High Street

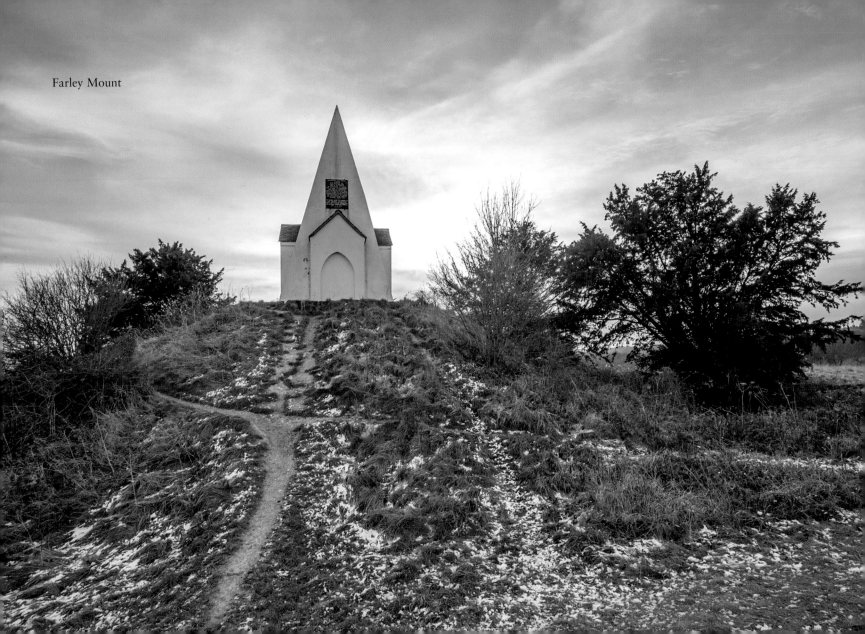

Farley Mount

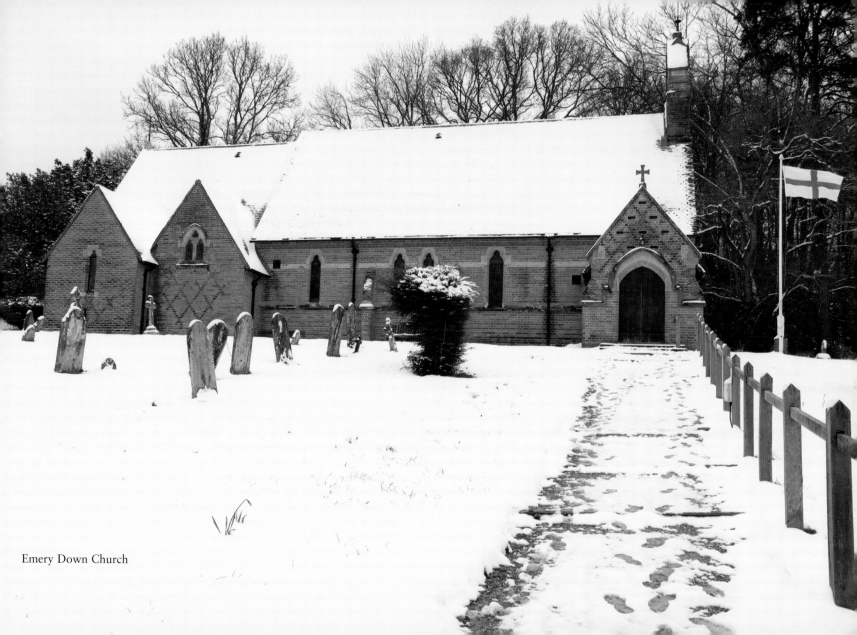

Emery Down Church

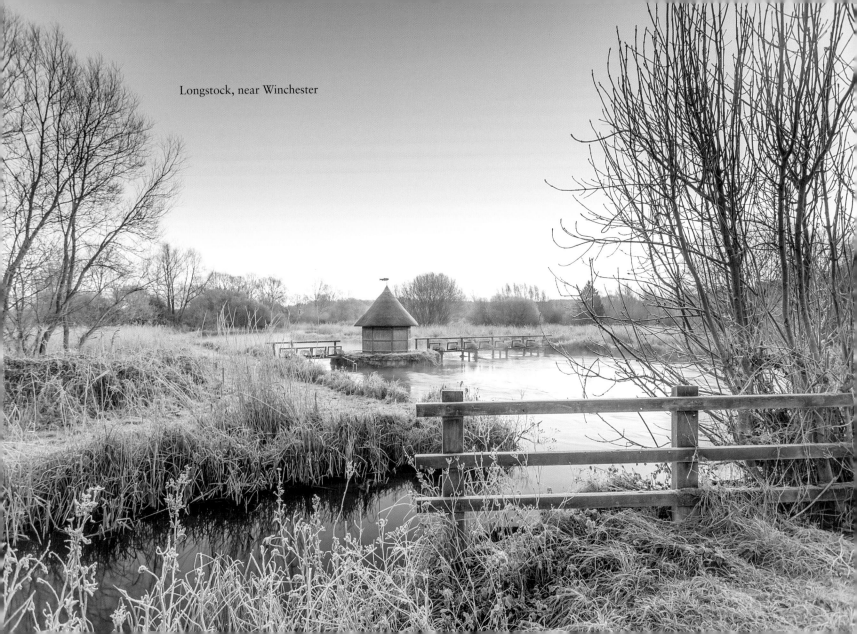

Longstock, near Winchester

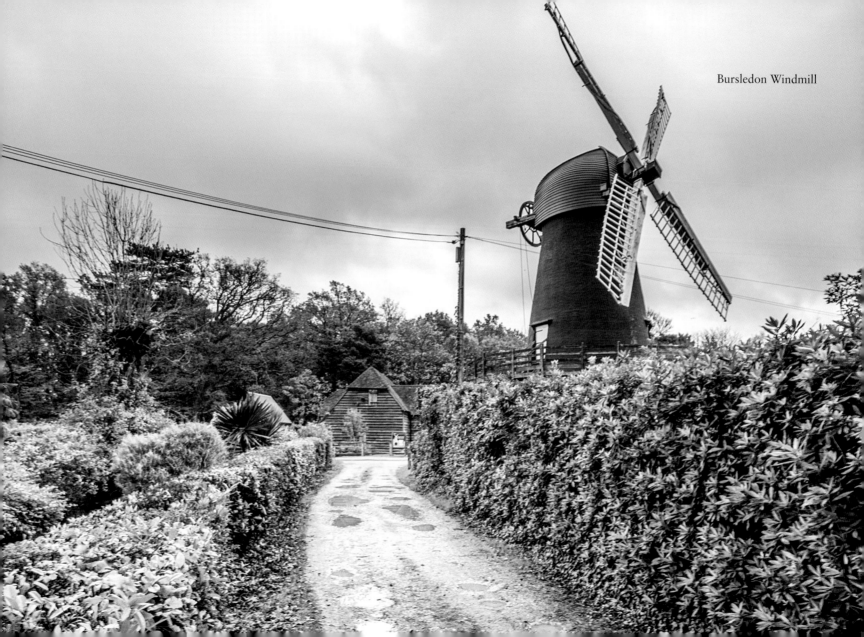

Bursledon Windmill

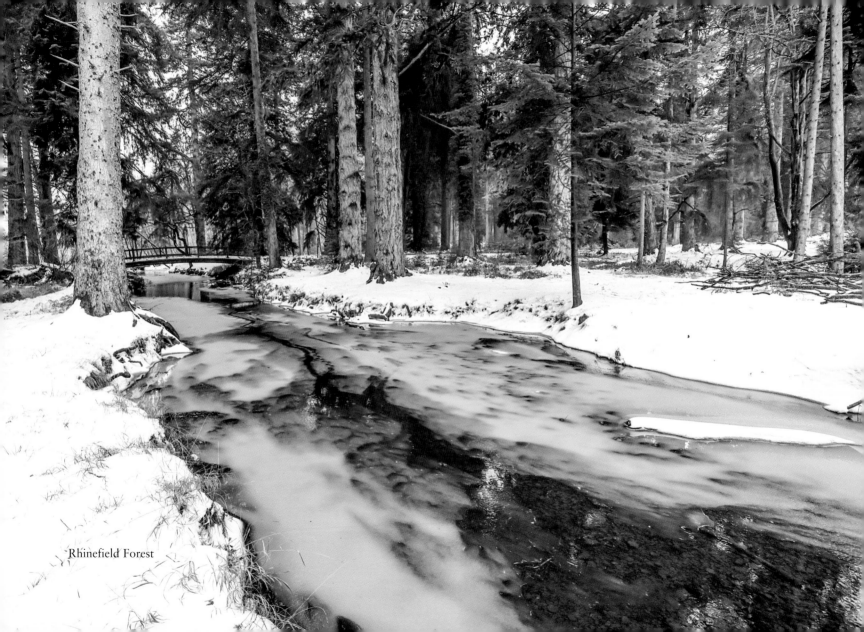

Rhinefield Forest

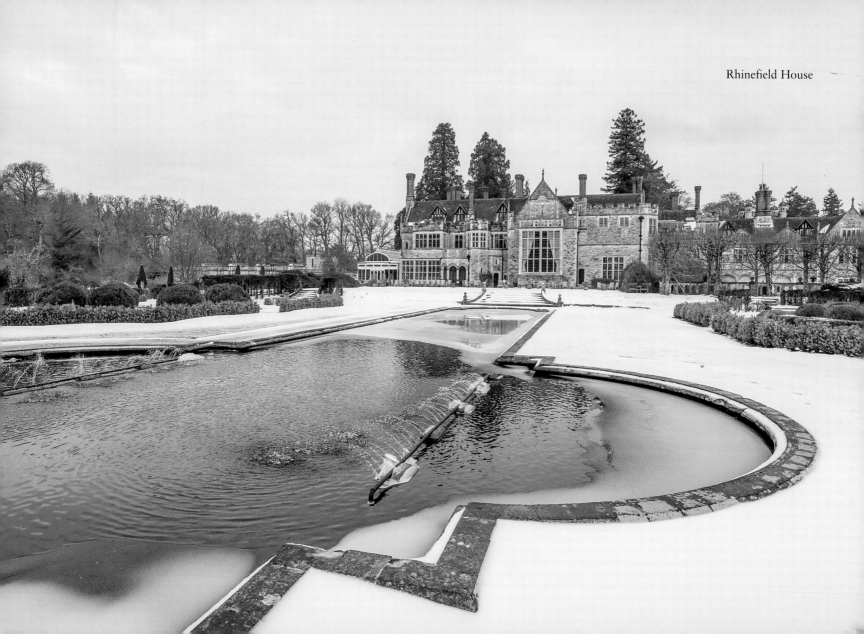

Rhinefield House

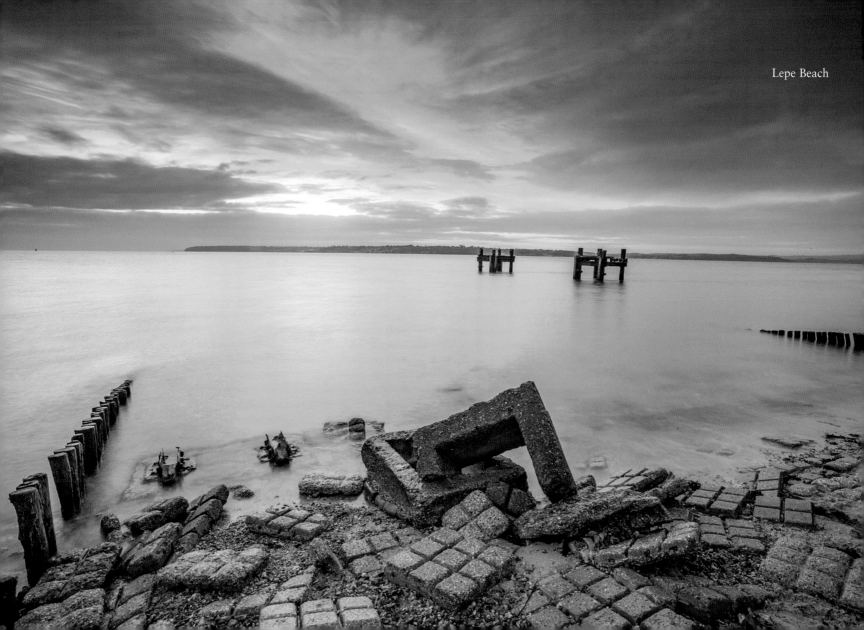

Lepe Beach

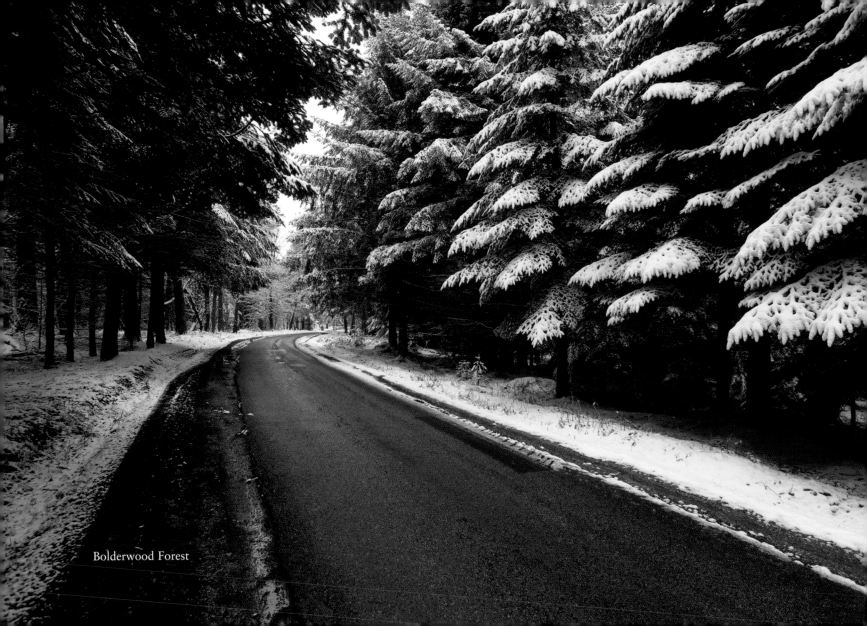

Bolderwood Forest

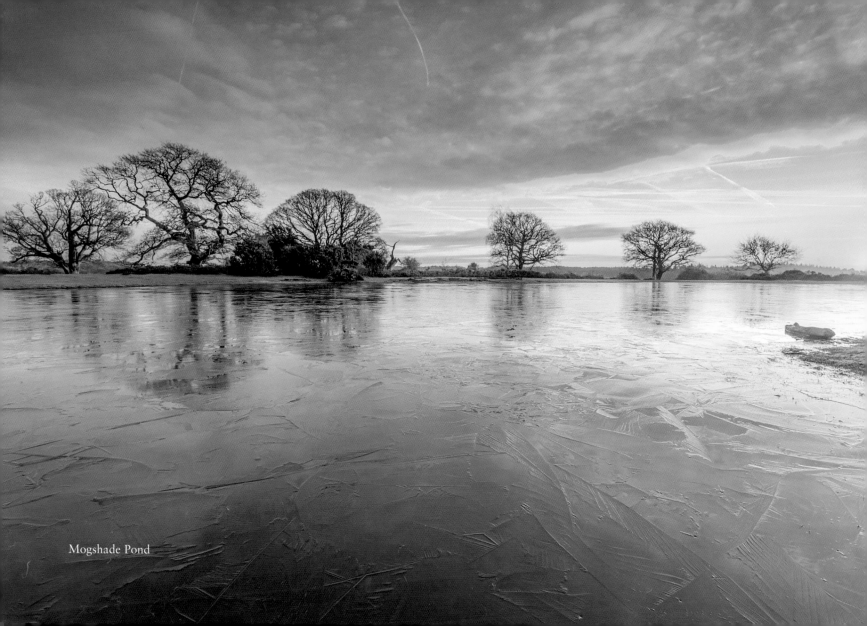

Mogshade Pond

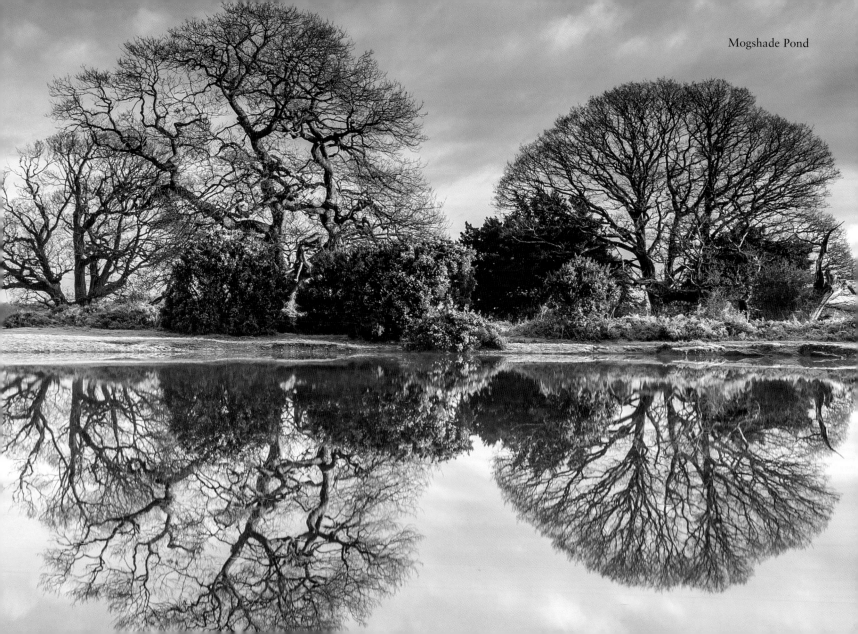

Mogshade Pond

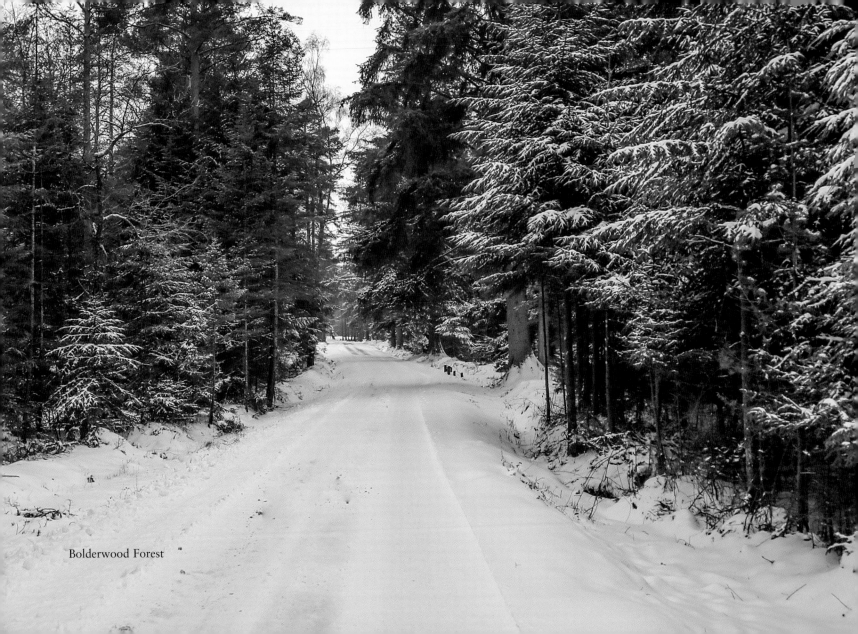

Bolderwood Forest

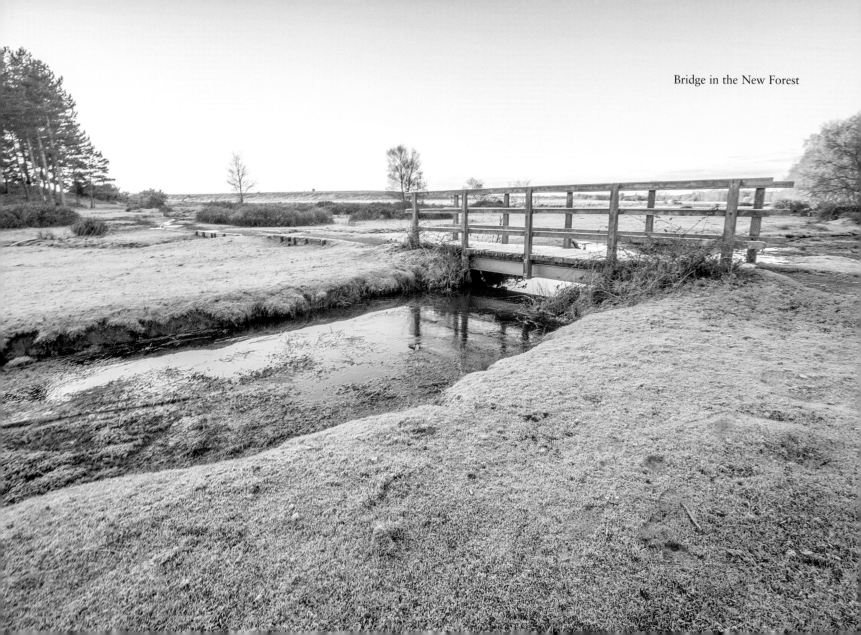
Bridge in the New Forest

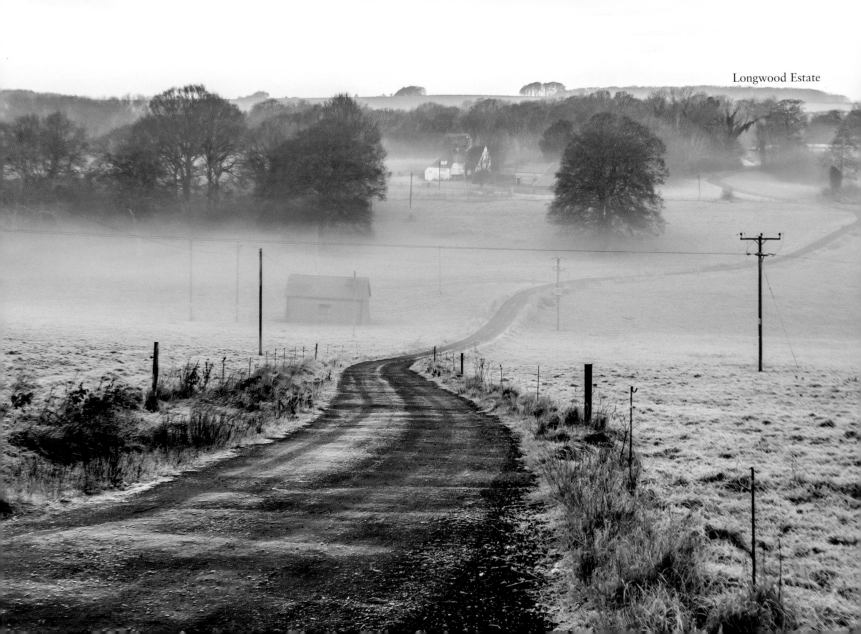

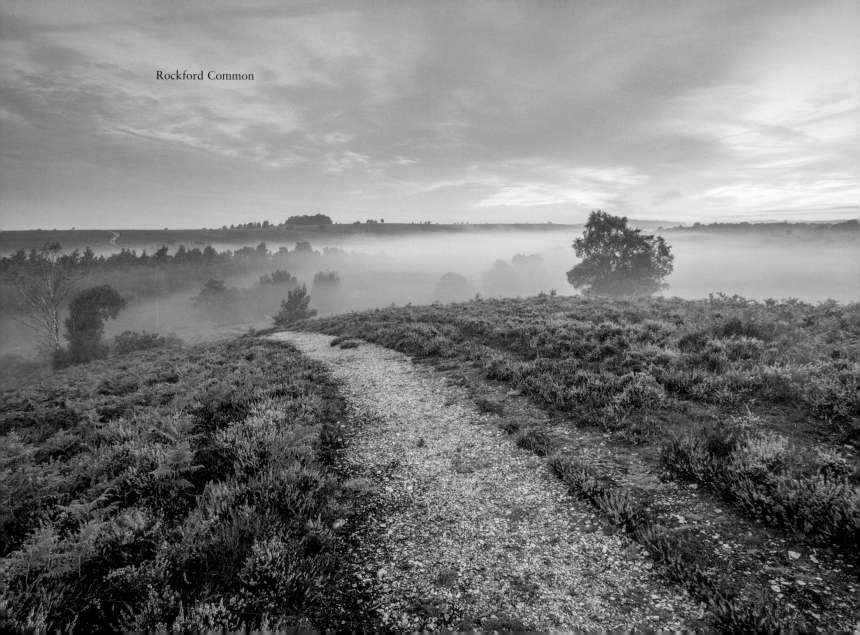

Rockford Common

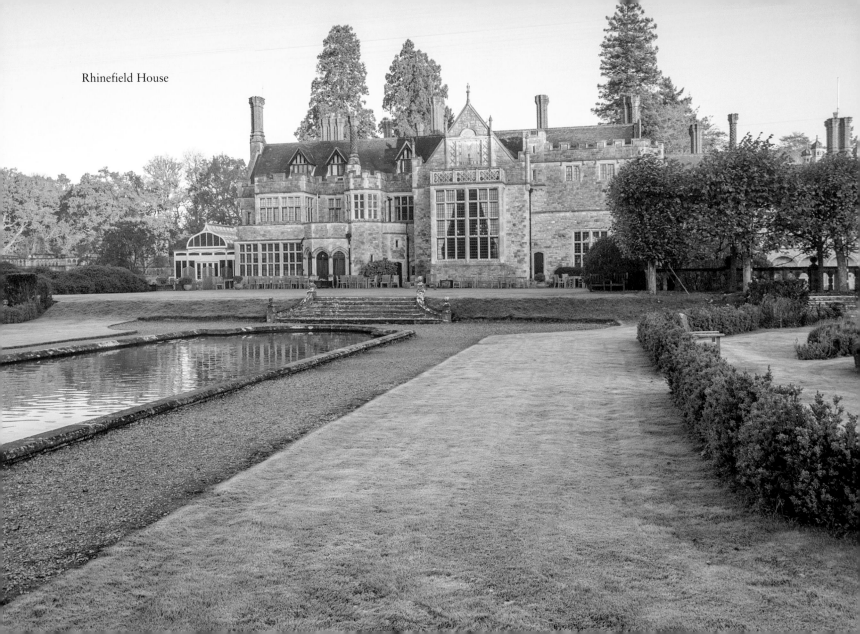

Rhinefield House

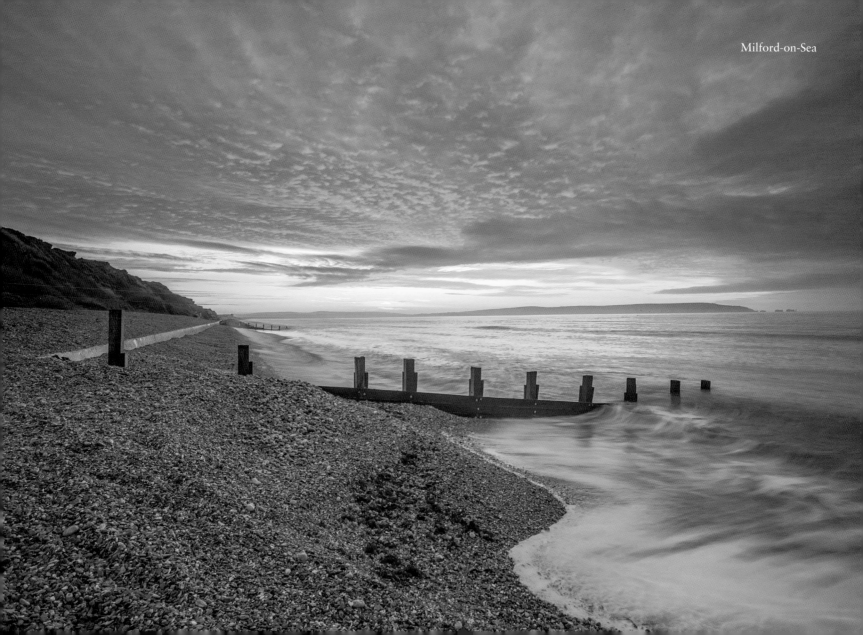

Milford-on-Sea

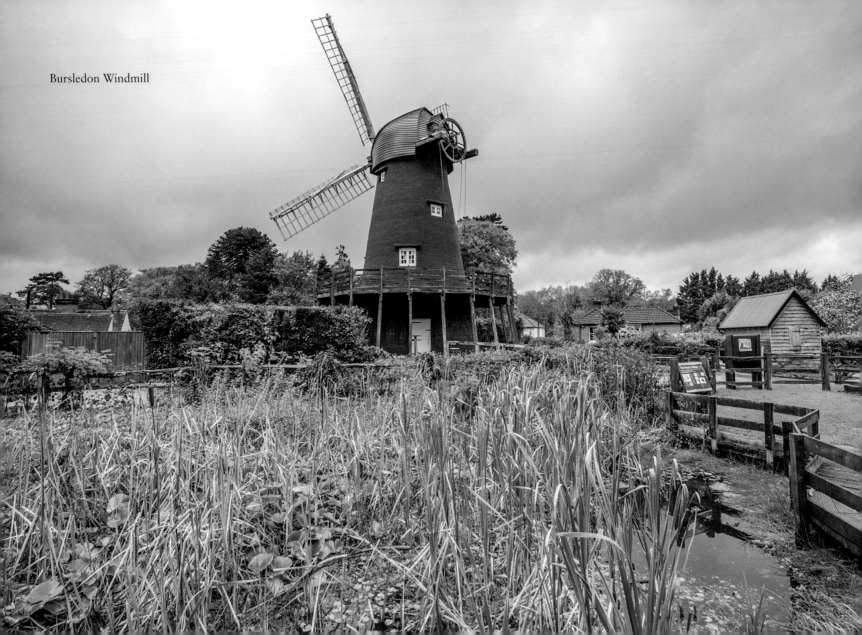
Bursledon Windmill

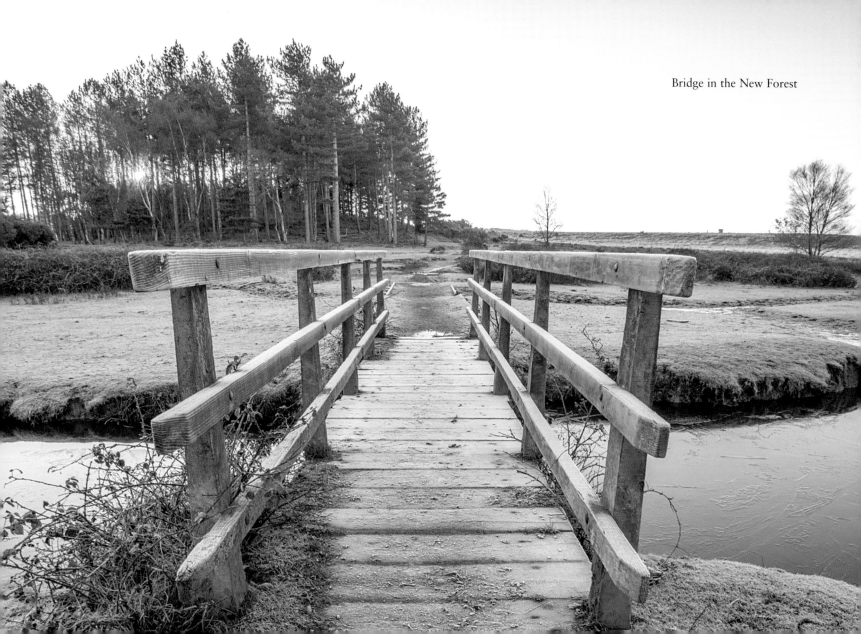

Bridge in the New Forest

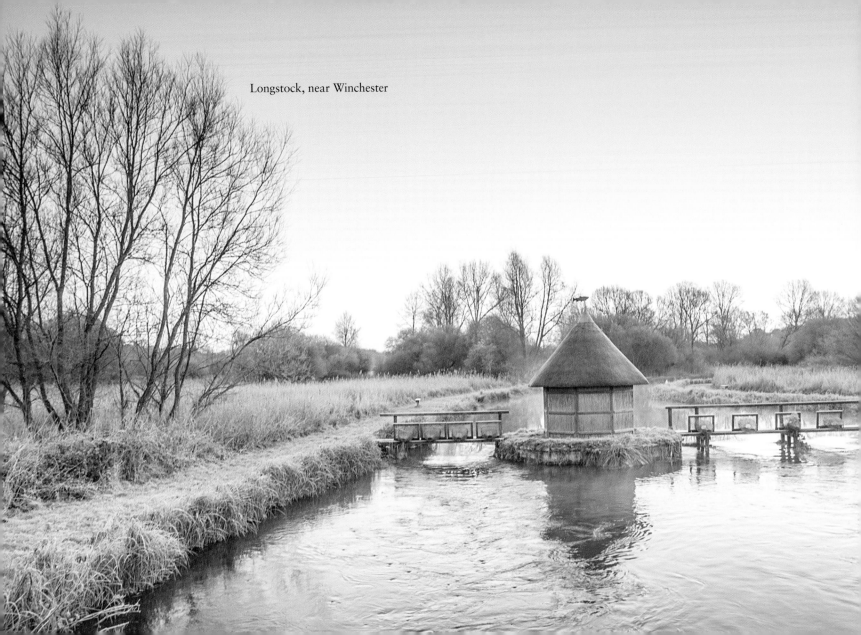

Longstock, near Winchester

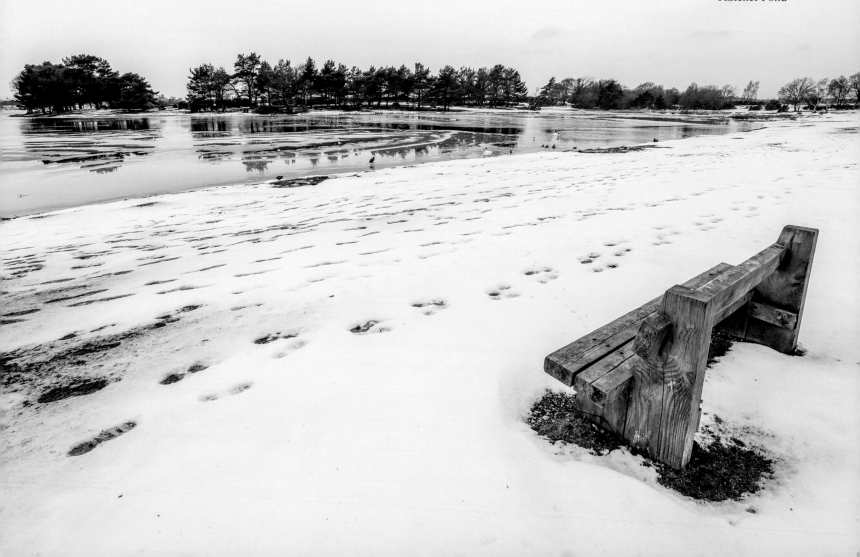

Hatchet Pond

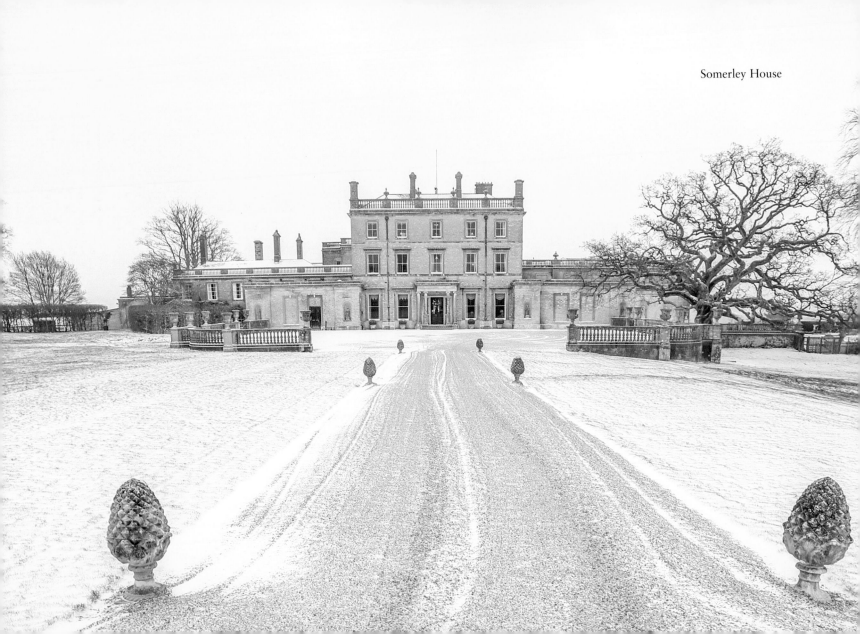

Somerley House